The College History Series

VALDOSTA STATE UNIVERSITY

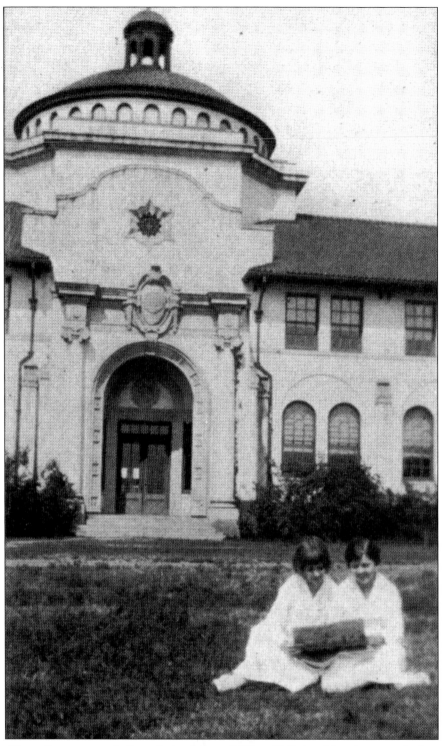

WEST HALL. Two young ladies sit in front of West Hall in this photograph from the 1925 *Pinecone*.

The College History Series

VALDOSTA STATE UNIVERSITY

DEBORAH SKINNER DAVIS

ARCADIA
PUBLISHING

Published by Arcadia Publishing
Charleston SC, Chicago IL, Portsmouth NH, San Francisco CA

Printed in the United States of America

Library of Congress Catalog Card Number: 00-112078

For all general information contact Arcadia Publishing at:
Telephone 843-853-2070
Fax 843-853-0044
E-Mail sales@arcadiapublishing.com
For customer service and orders:
Toll-Free 1-888-313-2665

Visit us on the Internet at www.arcadiapublishing.com

This book is dedicated to my husband, Alan,
and my daughter Ruth.
Their love and support made this project easier,
and our shared love of history made it exciting.

CONTENTS

ACKNOWLEDGMENTS

I would like to thank Nan Canington for her eye for detail and the 35 years of experience that allowed her to identify the people and events in many of these photographs. Cindi Smatt, the archives student assistant, did a wonderful job of scanning, manipulating, and organizing the images. Trying to keep ahead of Cindi propelled the project forward. My husband, Alan Bernstein, edited the final proofs and eliminated a lot of mistakes. Rex Devane, the Odum Library, and the Reference Department all helped to make this book possible. I would like to express special gratitude to President and Mrs. Hugh C. Bailey, whose support for the archives, for the preservation and dissemination of the history of the school, and for this project, have meant so much.

INTRODUCTION

Valdosta State University, located in Valdosta, Georgia, is one of the University System of Georgia's two regional universities. From its opening in 1913 as a women-only normal college, with a two-year course in teacher preparation, it has grown to a thriving university of some 9,000 students offering degrees from the associate to the doctorate. As a regional university, Valdosta State is charged with meeting the professional and general educational needs of its South Georgia service area, which stretches from the Atlantic to Alabama, encompassing 41 counties and 31% of the land area of the state. While it draws students from 48 states and 50 countries, it never forgets its main constituents, the people of South Georgia. Its programs, including those at the graduate level, are developed with specific reference to the professional educational needs of the area.

This regional perspective is entirely consistent with the university's founding and history. In 1906, a group of local legislators and concerned civic leaders worked hard for the passage of legislation to establish a college, which was to be named the South Georgia Agricultural, Industrial, and Normal College. At that time, Valdosta, Georgia, was a prosperous cotton city and served as the capital of the Sea Island Cotton Empire. Since Valdosta is located exactly in the east-west middle of the state, close to the Florida state line, a college here could provide quality, economical education for local young people and supply better trained teachers for South Georgia. In the earlier part of this century the differences between the North Georgia cities and rural Georgia were very marked, especially in education.

The school was founded in 1906. Col. W.S. West led the legislation through the Georgia Senate, and C.R. Ashley and E.J. McRee shepherded it through the House. However, no funds were appropriated for it until 1911, when the state allocated $25,000. The city raised $50,000, and Colonel West gave the property that is now the main part of campus to the state for use by the new institution. With the land and money in hand, the trustees then hired a president and contracted for a building. The president chosen was Richard Holmes Powell (1875–1947), whose background included work as a principal, college English professor, department head, and at the time of his appointment, State Superintendent of Rural Schools in Georgia. His energy and enthusiasm shaped the development of the college for its first 22 years, and his travels in the West led him to choose the Spanish Mission style of architecture for the institution's buildings, a style that has been maintained throughout the years

The school opened as South Georgia State Normal College (SGSNC) in January of 1913, with three college freshmen and 15 sub-freshmen. At that time, schools in various areas of the state had different levels of accreditation, and only students from "Class A" schools could enter directly into college classes. When the college began, a training school was also opened to prepare students for college level work and to provide a place of pedagogical experimentation for the college's students. This elementary school soon filled to capacity and, in the first few years of the college's existence, was by far the most successful part.

The early students were required to wear a school uniform, and each paid $10 per year for tuition and $12 per month for food and board. (Of course, each student supplied her

own silver knife, fork, and spoon.) Most came to be teachers and studied subjects from literature to physics to agriculture. In 1922, the school became a four-year college and the legislature changed the name to Georgia State Womans College (GSWC). By that year, the school had grown to 402 undergraduates and the training school to 108 students.

The school remained GSWC until 1950. Over the years, the academic program was expanded and extracurricular activities broadened. The early years of GSWC saw the continuation and strengthening of some SGSNC traditions. A May Day festival became an annual event, featuring elaborate skits, dances, and sports exhibitions. A May Queen and her court paraded in procession across the school grounds before a large campus and community audience. The joyous celebration concluded with dancing around the Maypole. Another "Old English" tradition honored at the school was the Old English Christmas Feast, complete with a Lord of Misrule, a fool, everyone dancing the minuet, and the presentation of the boar's head. These two festivals required months of preparation and every student dressed in costume.

The financial hardships of the Depression brought major changes to GSWC. The training school, popular with the town from its inception, was ordered to close in 1933 by the chancellor, and the school was made a four-year liberal arts college. Teacher training was drastically de-emphasized for five years or so. Also, President Powell, head of the college for 22 years, was made dean of the Coordinate College in Athens, in part because of controversy surrounding the closing of the training school. Dr. Jere M. Pound (1864–1935), president of the Georgia Teachers College, was sent to Valdosta. However, his tenure at GSWC lasted less than a year before he had to go on sick leave. He died a year later in 1935.

Dr. Frank Robertson Reade (1895–1957) assumed the job of acting president in 1934, and on Dr. Pound's death became president. Dr. Reade was the consummate liberal arts president for the new liberal arts college. During his tenure, New Deal programs enabled the school to expand physically from three to seven buildings. The Powell Library, dedicated by Eleanor Roosevelt, was a centerpiece of this construction. During World War II, GSWC emphasized politics and science in its curriculum, and, in 1943, the B.S. degree was added. Extracurricular activities centered around projects designed to aid the war effort such as scrap metal drives, USO dances, a War Bond scholarship campaign, and Red Cross activities. Moody Airfield, located nine miles from campus, provided the male participants for many patriotic parties.

Dr. Reade served until 1948, when failing health forced him to retire, and Dr. Ralph Thaxton (1901–1982) took the helm of GSWC. He came to GSWC from the University of Georgia, where he had served as professor, dean, director of admissions, and registrar. Soon after Dr. Thaxton began his service, the board of regents, acting on the advice of a committee which had examined the whole University of Georgia System, declared that in 1950 GSWC was to become a co-educational institution—Valdosta State College.

The coming of men to campus made immediate and lasting changes at Valdosta State. The elaborate costumed festivals came to an end early in the 1950s with more co-ed events taking their place. Dances and beauty contests took the place of the May Queens and Christmas festivals. Within a few years, most of the extracurricular activities were male-led. In fact, by 1956 men on campus outnumbered the women. Greek organizations were formed, with fraternities leading the way, and inter-collegiate athletics became a part of campus life when the Rebels, an all-male basketball team, was formed.

The focus of the school broadened as well. Programs in pre-medical, pre-dentistry, and pre-pharmacy were added, and the sciences became more prominent. Business became a popular major after 1950, and the education department began expanding its secondary offerings. However, the college's tradition of bringing in students from South Georgia, an area historically underserved educationally, continued. Many of the students in the 1950s and 60s, who participated in Greek Life, athletics, Rat Day, and the typical extracurricular events of college life, were the first students from their families to attend college.

Under Dr. Thaxton's tenure, the college integrated peacefully in 1963. Over the next decade the college added African-American students, faculty, and administrators, and to this day, it works to promote diversity in all areas of campus life. Its minority recruitment record has been exemplary, with 21% of the university's current students being African American.

Dr. Thaxton retired for health reasons in 1966, and Dr. S. Walter Martin (1911–2000), former president of Emory University and vice chancellor of the University System of Georgia, assumed the presidency. He presided over a time of physical expansion of the school, including the construction of such buildings as the Odum Library, the Education Center, the Fine Arts Building, the College Union, a science administration building, and six dormitories. The student body grew, the School of Nursing was established, and many programs expanded, including those in graduate education.

When Dr. Martin retired in 1978, Dr. Hugh Coleman Bailey (b. 1929) assumed the post. He had been vice president for academic affairs and dean at Francis Marion College in South Carolina. Since 1978, under Dr. Bailey, the school had doubled in size from 4,500 to 9,000 students. From 1978 to 1993, numerous programs were added and existing courses upgraded, resulting in the early 1980s in an endeavor to make VSC a university. Throughout the 1980s the college established off-campus sites and course offerings across South Georgia and began receiving state and federal grant funds to develop curricula and programs.

In 1993, all the hard work and planning paid off. Valdosta State College became Valdosta State University, the second regional university in the University System of Georgia. In recent years, the master of social work has been a growing program, as have masters degrees in public administration, nursing, business, and speech-language pathology. In 2001, VSU will begin offering a master of library and information science degree. VSU has established partnerships with area colleges and universities, offering courses on four two-year college campuses and two military bases. It offers extensive courses through distance education; in 1999, it reached 3,338 students through this medium. It has an active international program and sponsors faculty exchanges on every continent in the world. The College of the Arts continues its long tradition of excellence, begun with the frequent plays and festivals of SGSNC and highlighted today by sponsorship of the Valdosta Symphony Orchestra. VSU competes in NCAA Division II athletics in the 18-member Gulf South Conference.

Since becoming a university, VSU has virtually eliminated its remedial studies program and has raised its admission standards substantially. In the 1990s, a new building boom began on campus, but careful attention has been given to maintenance of the Spanish Mission style, which is a distinguishing feature of the university. Despite its impressive growth, technological achievements, and international connections, the school remains grounded, as always, in its concern for the students' development while meeting the educational needs of South Georgia.

The images in this book, with a few exceptions, come from the collections of the Valdosta State University Archives. These photographs were donated over the years by alumni, by the student paper and annual, and by various administrative offices. Citations with the captions often point to where the image first appeared in print. We at the archives hope you will enjoy this glimpse of Valdosta State.

(This text is based on an article written for the *New Georgia Encyclopedia* (online) by Deborah S. Davis.)

One

THE EARLY YEARS: 1906–1922

South Georgia State Normal College (SGSNC) opened in 1913, seven years after the school was founded. SGSNC's mission was primarily teacher training, and the school was ostensibly a two-year college. Since Georgia's high schools at that time had varying levels of accreditation, pre-college work was required of many students and this two-year college actually offered more than two years of course work. A training school, composed of elementary and later high school students, was a popular part of the college.

The early challenges faced by President Richard Powell and the faculty included a shortage of funds and working within a system that somehow believed that "good educational facilities for women can be provided at relatively low rates." (Annual Report, 1923-24, Minutes of the Board). However SGSNC grew successfully in the nine years of its active existence. It began many customs and traditions, such as Christmas Fest and May Day, which bloomed over the next 40 years. From the first year, a tradition of excellence in theater and performance developed. Both the students and the faculty were very active in war work, mainly through the Red Cross. The pictures in this chapter are the oldest and rarest of the Valdosta State University Archives collection. They and the text, taken from primary sources of the period, show an active, new, almost "frontier" school.

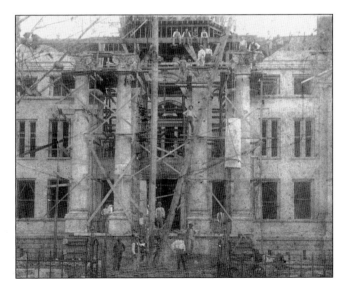

BUILDING THE VALDOSTA COURTHOUSE 1904–1905. By the early 1900s, Valdosta was a vigorous and prosperous small city. The city looked for ways to commemorate its position and "in keeping with Valdosta's forward thrust and thirst for progress, the old courthouse came down," and a new one went up. Note the enormous columns raised one section at a time. Each section weighed 11,000 pounds. (*Lowndes County Historical Society Newsletter*, 6/ 9/74.)

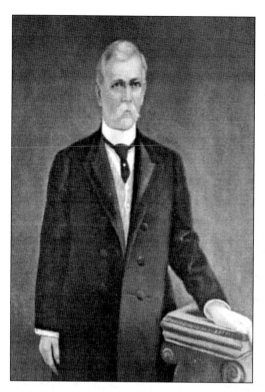

HON. WILLIAM S. WEST, 1849–1914. "He was the main spirit in bringing the South Georgia State Normal College to Valdosta." Colonel West was president of the Georgia Senate at the time that South Georgia State Normal College was created in 1906. His leadership assured the existence of the college. He was a gifted teacher, lawyer, politician, senator, and farmer. (*Valdosta Daily Times*, 12/22/14, p. 1.)

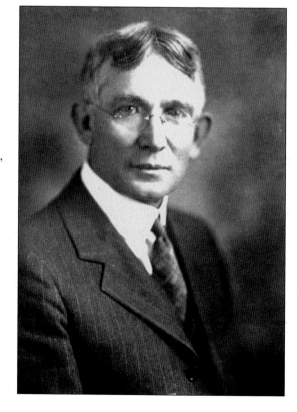

RICHARD HOLMES POWELL, PRESIDENT, 1913–1933. "Born at Blakely, Georgia, March 3, 1875. He earned his A.B. degree at Mercer University in 1894, his M.A. degree at the University of Colorado in 1898, and . . . [doctoral] work at the University of Chicago. His varied experiences in school work included terms as principal of the Tennille, Ga. Institute, Head of the department of English of the New Mexico Normal Institute, Associate professor of English at Colorado State Teachers College, and Head of the department of English at Georgia Normal and Industrial College, Milledgeville." (*Campus Canopy*, 4/18/68, p. 4.)

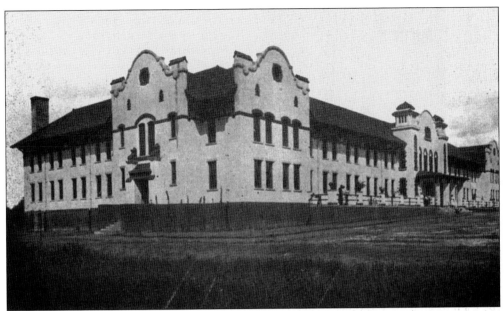

CONVERSE HALL. Converse Hall (first called Building One) was named for W.L. Converse, who had advanced $15,000 for the construction of the first building. It "is a combination dormitory and administration building . . . only two stories high, thus preventing the injury of much climbing of stairs. The rooms are all well ventilated [with] running water, hot and cold, in every room. Ample toilet and bath facilities are conveniently placed. The furniture, though simple, is neat and specially adapted to dormitory purposes . . . There is not a better building of its kind in the South." (Announcement of *SGSNC Bulletin* 1913, p. 12.)

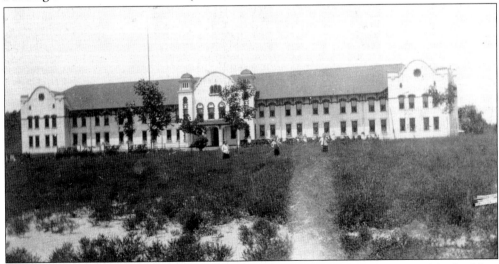

SCHOOL IN THE WEEDS. The president's annual report gives a less effusive view of the building after living in it for a year: "When school opened, there was no driveway or approach to the building, no bridge over the swamp between the college and the city, and no sidewalk. . . . Immediately about the building were piles of all kinds of rubbish. . . . In the rear was a pond where myriads of mosquitoes bred last year." Through several years of draining, fixing, planning, and planting, the building finally did live up to its early description. (President's Annual Report, 1913, *Minutes of the Board*.)

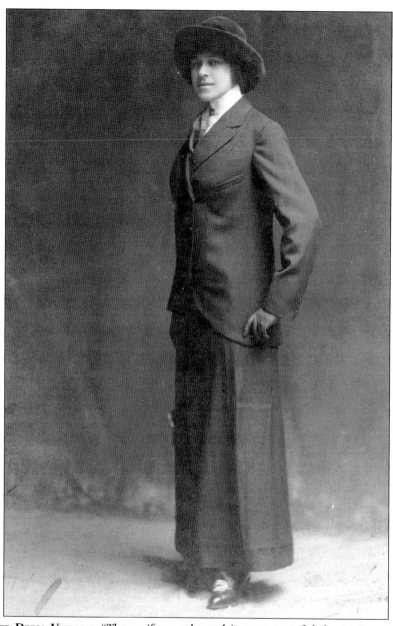

THE WINTER DRESS UNIFORM. "The uniform adopted is neat, tasteful, hygienic, comfortable and economical. As all students dress alike, there are not distinctions among students on the artificial basis of clothes, and there is no temptation to large expenditures in a rivalry to out dress one another. In selecting the style and material of the uniform, consideration has been given to the climate and to the fact that people work better when they are dressed comfortably." (*SGSNC Bulletin*, 1913–1914, p. 23.) Each girl had to have a winter dress uniform, "one coat suit of navy blue serge, lined with gray Belding silk, made according to college specification, which endeavor to provide for comfort, durability, and a style adapted to girls of varying ages. Price $13.75 . . . This suit will be worn on Sunday and on other formal occasions (not for evening dress) from soon after the opening of the school in September until approximately April first." (*SGSNC Bulletin*, 1913–1914, p. 23.)

THE SPRING DRESS UNIFORM. This uniform was worn for church and other events after April 1, and for all evening occasions throughout the year. When worn as the "spring uniform," it consisted of a white skirt, white waist (blouse), Robespierre collar; white crepe tie, straw hat, black or white shoes, and hose to match. The spring hat (worn after March 15) was white straw, with black velvet band and red and black chord (the school colors). (*SGSNC Bulletin*, 1915–1916, p. 26).

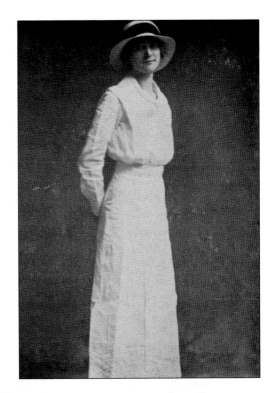

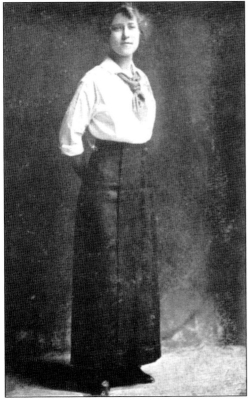

THE EVERYDAY UNIFORM. The everyday uniform, modeled by Lucille Arnold, consisted of a "blue serge skirt, white waist, Robespierre collar, blue silk Windsor tie." The uniform rules specified a particular pattern for the skirts, Butterick #5856, and that material may be bought in Valdosta from Varnedoe and Company. Each girl had to bring 12 waists (or blouses) of Madras, Percale, or Killarney cloth, 12 Robespierre collars, and 6 high collars to go with the waists. (*SGSNC Bulletin*, 1915–1916, p. 28.)

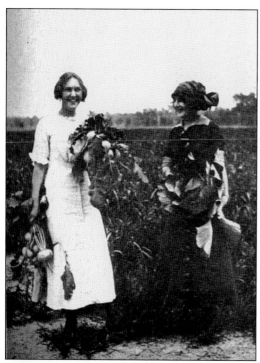

FRESH FROM THE SCHOOL GARDEN. The "superior healthfulness" of the school dictated "vegetables and eggs are produced on the grounds and are always fresh." SGSNC offered coursework in agriculture, and "the students in these courses are given the first hand experience . . . through the practical work on the School farm . . . About two acres are used for growing such crops as are most useful to the institution." (*SGSNC Bulletin*, 1913–1914, p. 35-36.)

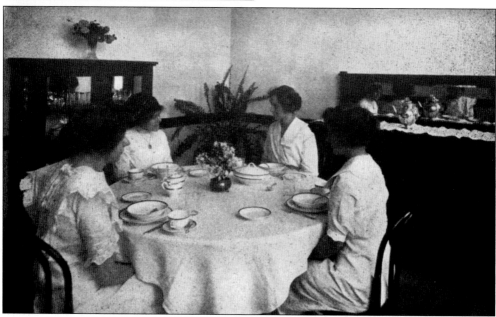

BREAKFAST SERVED BY STUDENTS IN DINING ROOM OF THE HOME ECONOMICS DEPARTMENT. In addition to teacher training, SGSNC offered a wide variety of courses from Physics to Home Economics. The various Home Economics labs are "in quality and completeness . . . the equal of the best in the South . . . The mission oak furniture in the model dining room is of simple but beautiful quality. The dining room, so ideally adapted to the proper serving of meals, is at the same time of such moderate cost as to be entirely practical for the home of any student." (*SGSNC Bulletin*, 1913–1914, p. 32.)

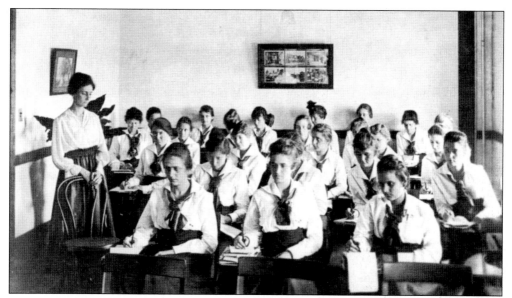

A Class of SGSNC Students. "As to course of study, the work is broad and thorough. Besides the professional work necessary to the training of teachers, there is thorough and vital training in the usual academic studies and the subjects pertaining to home activities and arts." The women at SGSNC took courses from Chemistry to Nature Study to Literature to Latin to Psychology. (*SGSNC Bulletin*, 1913–1914, p. 10.)

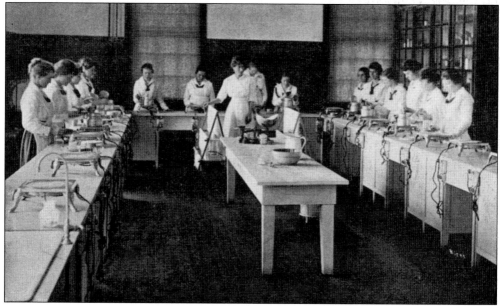

A Class in Cooking. "The cooking laboratory [has] individual desks, each . . . supplied with modern equipment. These with the electric range, sink, refrigerator and general cooking equipment for the collective use of the class, make the laboratory equal to any demand which may be made upon it." (*SGSNC Bulletin*, 1914–1915, p. 40.) The total spent the first year for equipping the sewing room, cooking lab, and model dining room was $535.40. The desks above with gas fixtures cost $130.00. (President's Annual Report, 1913, *Minutes of the Board of Trustees.*)

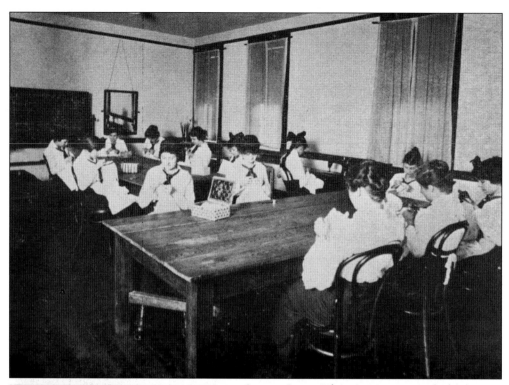

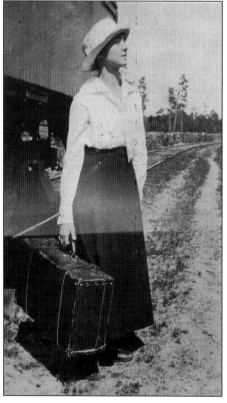

SEWING CLASS. "Plain Sewing . . . includes . . . hand sewing, fundamental stitches, care and repairing of clothing, etc., [and the] use of machine and its attachments. It includes also, drafting of patterns for use in making garments and the actual making of a complete set of under garments, a shirtwaist and a cotton dress completed. Each student is required to keep an expense account . . . to compare prices and wearing qualities of home made and factory made garments and to plan a simple wardrobe." (*SGSNC Bulletin*, 1916–1917.)

DIRECTIONS TO STUDENTS COMING TO COLLEGE. "1. Be sure your application has been accepted before leaving home . . . 2. Leave home so as to reach Valdosta in the daytime . . . 3. Write your name on the trunk tag sent to the college and tie it on your trunk before leaving home . . . 5. Do not give your trunk check to a drayman or any one at the depot. Give the check and 25 [cents] to the matron; On reaching the College, report at once to the matron . . . 6. In coming to College wear the blue serge skirt and the waist of the uniform." (*SGSNC Bulletin*, 1915–1916, p. 22.)

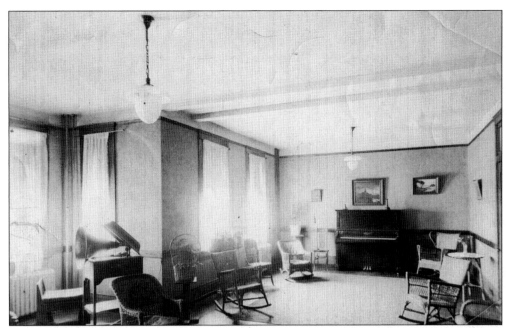

PARLOR, CONVERSE HALL. A necessary part of any dormitory is a parlor for entertaining, sitting, and visiting. The beginning budget for furnishing the parlor was $50 in 1913. (Annual Report of the President, 1913, *Minutes of the Board of Trustees.*)

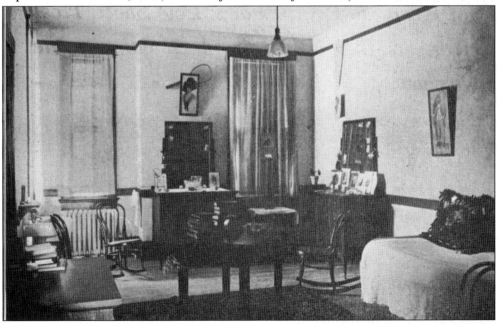

A TYPICAL DORM ROOM AT SGSNC. "We found [the rooms] neatly and modestly furnished, showing every sign of comfort . . . The rooms are not very large nor do they appear greatly crowded although they contain a bureau, a table, two rockers, two straight chairs, three beds and mattresses, a rug, two window shades, two pairs of curtains and a stationary washstand which supplies an abundance of hot and cold water." (Submitted by Mrs. W.S. West, Report in *Minutes of Board of Trustees*, 1916–1917.)

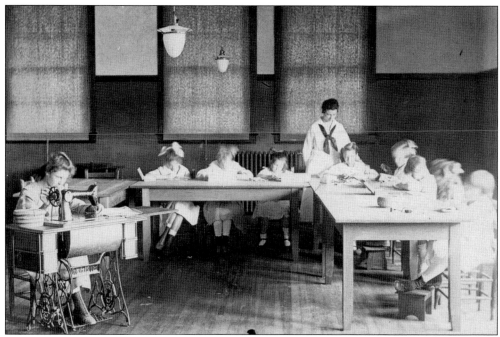

A ROOM OF THE TRAINING SCHOOL. As part of its mission, the school opened a "Training School" consisting at first of grades 1, 3, and 5. It quickly expanded to include at times all elementary grades and high school and was extremely popular. The training school lasted from 1913 to 1933, when it closed due to lack of funds. The picture is of a training school sewing class in the teens.

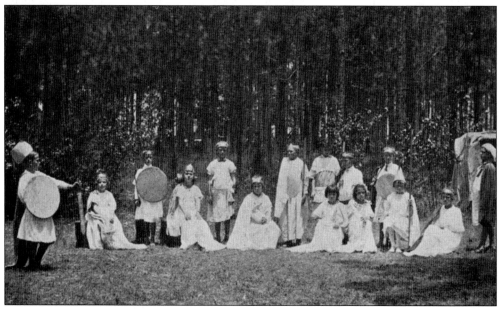

DRAMATIZATION IN THE TRAINING SCHOOL. "Perhaps the most perfectly organized division of the college, so far, is the training school. The demand for admission of other children to our training school classes is so great and so insistent as to be a very great embarrassment to us." (Annual Report, 1914, *Minutes of the Board of Trustees.*)

20

THE CHAPEL. While the school is officially "unsectarian, . . . religious life of the students is in every way encouraged. Students are expected to attend the churches of their own membership every Sunday." (*SGSNC Bulletin*, 1914–1915, p. 13.) In addition, "the students of their own accord have instituted a vesper service, which is held in the college chapel on Sunday evening just after supper. It has already made its place in the hearts of the students." (*SGSNC Bulletin*, 1914–1915, p. 14.)

A TENNIS GAME FROM THE COVER OF THE FEBRUARY 1918 *PINEBRANCH*. "Two class periods a week [for physical training] are required of all students unless a doctor's certificate is presented. The first part of the period is devoted to calisthenics . . . The last part of the period is given up to play, games, folk games, races and contests . . . Tennis and Basketball are encouraged and participated in throughout the year." (*SGSNC Bulletin*, 1916–17, p. 60.)

THE CLASS OF 1915. The Class of 1915 included Emily Andrews, Louise Chesney, Bessie Mann, Carrie Lee Murrah, Mattie Peek, and Julia Pinkston. The school in 1915 had a small enrollment of 65 students, but "the happiness and enthusiasm of the student body has been marked." (Annual Report, May 27, 1915, *Minutes of the Board of Trustees*.)

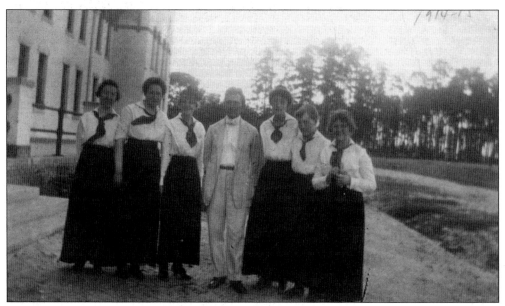

MR. POWELL WITH THE SENIORS, 1914–1915. President Powell writes of the year 1914–15: "The enrollment of students has been materially reduced by the effects of the European war . . . but the personnel [student body] has been better and more stable than ever before. The students who came at all came to stay." (Annual Report, 1915, *Minutes of the Board of Trustees*.) (Photo donated by Betsy Powell.)

ONE BIG FAMILY. SGSNC rules encouraged the close friendships of college with its rules. "Frequent visits home and with friends tend to take the minds of the students from their work and to produce general carelessness. The President must reserve the right to decline even parents' requests to allow visits [occasionally]." Pictured from left to right are (front row) Mable Bostwick, Sadie Culbreth, Billy Powell, Erma Bastwick, and Alfred Powell; (back row) Maude Hodges, Clyda Purcell, Carry Lee Murrah, and Gertrude Jones. (*SGSNC Bulletin*, 1913–1914, p. 16.)

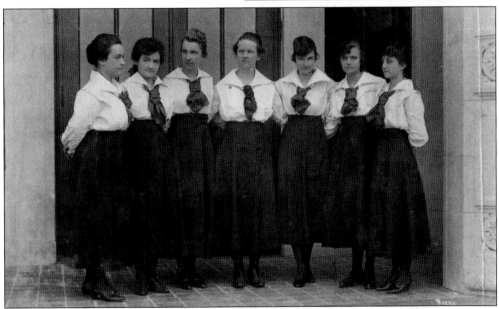

THE COURT—THE STUDENT SELF-GOVERNMENT. "The government of the student-body is a form of student self-government. There are certain specific regulations . . . necessary for the protection of students either from the thoughtlessness of fellow students or from outside interference, or else to guarantee promptness and efficiency in the co-operation of the whole group. In the carrying out of these regulations . . . the students are allowed as much liberty as is consistent with their own welfare." *(SGSNC Bulletin*, 1915–1916.) (Picture from *Pinebranch*, April 1918.)

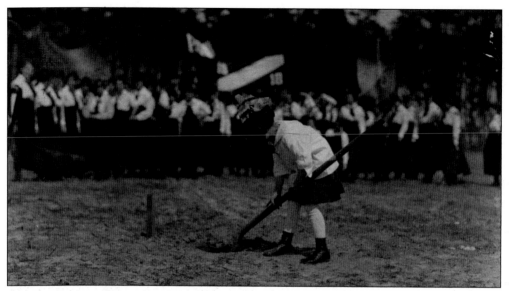

CAROLINE PARRISH (THOMAS) AT WEST HALL GROUND BREAKING. "When this little girl, a member of the first grade of the training school, broke the ground for West Hall in 1916 she did not know that she would grow up and become one day registrar of the college with offices in that same building. She is Mrs. Caroline Parrish Thomas, of Valdosta." (*Atlanta Constitution*, 1/16/38.)

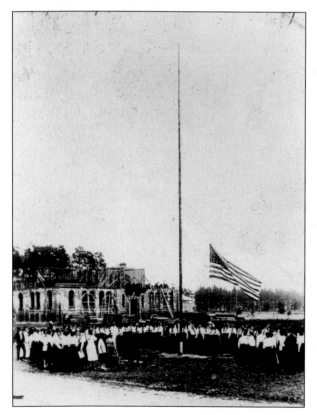

WEST HALL UNDER CONSTRUCTION, 1916. West Hall was completed in 1917. As Colonel West had died in December of 1914, the board decided to name the building in his honor. According to the students, the growth of the college had necessitated the new building. "For two years we lived fairly comfortably in . . . [Building One] but the school grew so rapidly that for the next two years we existed in such a crowded condition that at every turn our elbows met the ribs of our fellow students." (*Pinebranch*, December 1917, p. 2.)

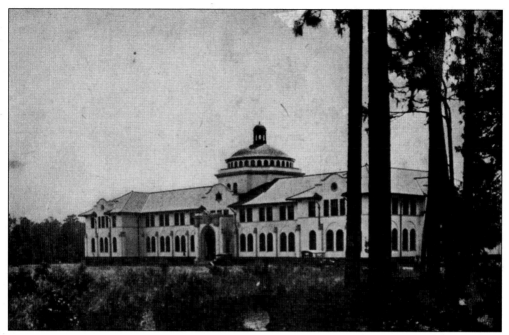

WEST HALL, 1917. "There it stood, its stately dome towering above its exquisite façade and its broad and graceful wings stretching boldly to either side. The rich, red tile of the roof and dome, the deep shadows cast by the overhanging eaves against the broad white walls, the multitude of arched windows—all contributed to produce a most pleasing effect." West Hall became the "administration" building, housing all classrooms, administrative offices, and the library. Building One became a dormitory. (*Pinebranch*, December 1917, p. 2.)

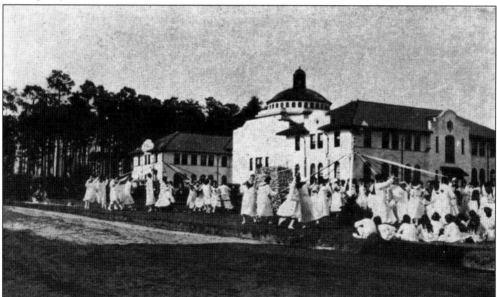

PLAYING AMONG THE FLOWERS OF SGSNC. One of the oldest traditions of the school was its English May Festival, which always featured dancing around the May Pole. (*Pinebranch*, February 1922.)

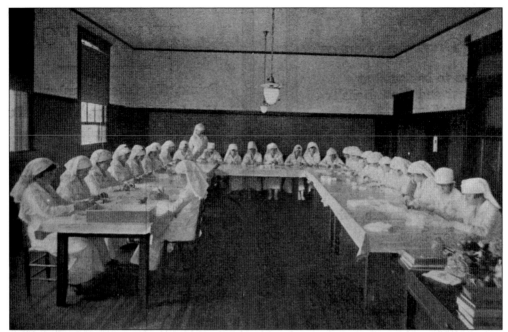

A Section of the Red Cross at Work during World War I. "On the day war was declared, the girls offered their services to the Secretary of War. The result was that on his suggestion the girls asked for gardens at home and canned a great many vegetables during the summer." (*Pinebranch*, February 1918) Every class has devoted one evening a week to Red Cross work—and the girls have up to date sent to France some 40,000 surgical dressings of all kinds. (Annual Report, 1917–1918, *Minutes of the Board of Trustees.*)

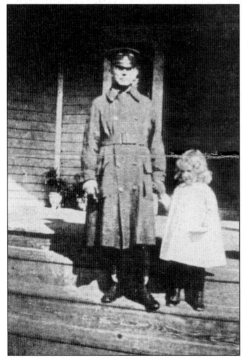

Dr. Powell and Daughter Betsy in the Fall of 1918 in Red Cross Uniform. In 1918, President Powell was granted a leave of absence to perform Red Cross work. He "felt that the service would by putting him in direct touch with the greatest movements of the times give him a better equipment for educational leadership in the coming days . . . " (Annual Report, 1918–1919, *Minutes of the Board of Trustees.*)

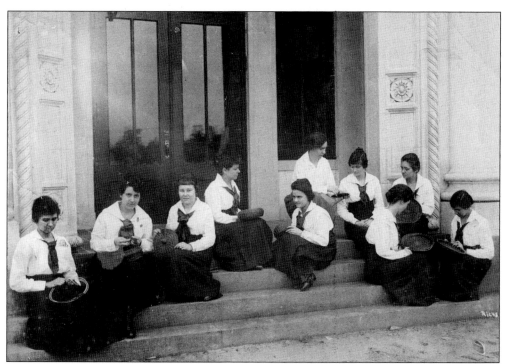

THE BASKETRY CLUB. "The Basketry Club is making beautiful baskets and studying the lives of basket makers. This work stimulates love for the beautiful; it develops the finer muscles and establishes coordination of those muscles with the brain; and supplies an excellent medium of expression." (*Pinebranch*, December 1917.)

MISS GALLAHER—THE FIRST DEAN OF WOMEN. Miss Gallaher was with the school from its first year as teacher of first and second grade in the training school. By the fall of 1915, she had moved up to "Head of College Home" and by 1922, after SGSNC became GSWC, she was named dean of women.

SGSNC Delegation to YWCA Conference, June, 1921, in Blue Ridge, North Carolina. Among those shown here are Ruby Meeks, Margery Moore (Latin and French professor), Mary Cobb, Eppie Roberson, Inez Sharpe, Mattie Stipe, Birdie Van Brackle. According to the *Bulletin*, "there is in the College a flourishing branch of the Young Women's Christian Association, of which about all the students are members." (*SGSNC Bulletin*, 1914–1915.)

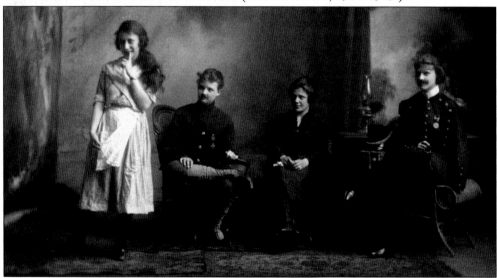

La Soire Francaise, SGSNC, February 26, 1921. Shown from left to right are Louisette, played by Louise Mendelsohn; Jacques, played by Mary Breedlove; Mme Phillippe, played by Marion Chauncey; and Pere Baudoin, played by Francis Dekle. "The scene of the play is laid in the home of a poor woman in Paris . . . [her son is visiting from the 'front.'] An old soldier . . . a friend of the family comes in to greet the young hero. The girl, Louisette, is a neighbor who has come in to help. The department cordially invites all who love France and are interested in its language." (VSU Archives.)

Two

GSWC AND THE TWENTIES: 1922–1929

In 1922, the board declared SGSNC a four-year institution and the name was changed in time for the 1922–23 school year to Georgia State Womans College (GSWC). The 1920s saw a loosening of the uniform restrictions, until finally only freshmen and sophomores wore them. The GSWC student may have looked fashionable, but she was responsible for her behavior to Miss Annie Powe Hopper. Miss Hopper, dean of women at GSWC for 20 years, began her task in the 1920s; she tried to "make women of them" and insisted on proper etiquette in all areas, from behavior to dress.

Four years of college life allowed for an expansion of creative experiences. The most elaborate and inclusive of college events were the Old English Christmas Festival and May Day. Both had roots in "English Tradition" and carried stylized elements forward from year to year. The Old English Christmas Festival always began with "Bringing in the Yule Log." A Lord of Misrule, a fool, and two heralds opened the occasion and directed activities. Skits, with costumed players singing and dancing, followed. Dancing the minuet in full 18th-century dress was always a part of the festival. The evening always closed with singing traditional carols by candlelight, usually including "Silent Night." May Day, of course, included dancing around the Maypole. A May Queen, elected by the student body, was carried in procession with her court across campus to a dais where she was crowned and presided over all activities. Plays, songs, and skits followed. For these two events all the students participated in costume and the preparation took months.

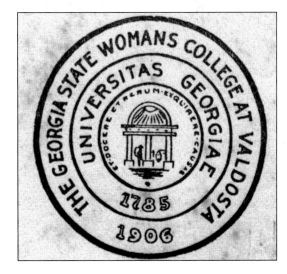

THE SEAL OF GEORGIA STATE WOMANS COLLEGE. On January 13, 1922, the board of trustees and the chancellor met and changed SGSNC into a "full fledged four-year college." And at the same time "it [kept] the two-year, or normal and junior college courses, whose excellence has made possible the rapid development of the institution." Later that summer, the legislature changed the school's name to Georgia State Womans College to reflect the new status. (*Pinebranch*, February 1922, p. 13.)

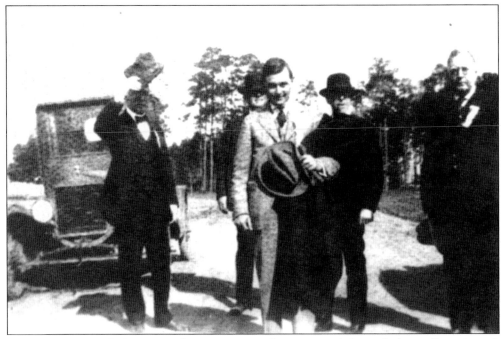

COLLEGE BOARD, 1922. Pictured is a group of men consisting of the college board, visitors, and Mr. R.H. Powell (president of GSWC) on the left with the lifted hat. (VSU Photograph Collection.)

THREE STUDENTS IN 1922. Pictured here, from left to right, are Mary Rhodes, Sadie Miller, and Lillian Lane. The GSWC uniforms are similar to SGSNC, but note the higher hemlines and shorter hair, indicators of the 1920s.

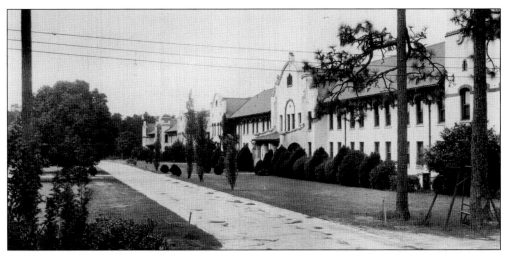

THE DORMITORIES: CONVERSE AND ASHLEY. "The College Dormitories are beautiful brick buildings, constructed and equipped . . . in the most modern way. Every room is a [sic] 'outside' room into which the sun shines at some time of the day. . . . The buildings and their equipment meet all requirements of modern, comfortable, convenient sanitary and refined living." The dormitories were named in 1924 after W.L. Converse and C.R. Ashley, "in recognition of their great services." (*GSWC Bulletin*, 1924, p. 12.)

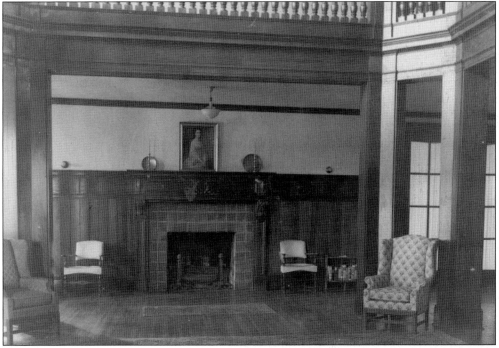

ASHLEY HALL. At one point during Ashley's construction, the school ran out of money and Dr. Powell had to seek an extra appropriation: "In its construction it came to be thought of as 'the house of a thousand cares.' Now that it is done it has already begun its career as the house of a thousand delights." This rotunda is a distinctive feature of the building and was used for teas, parties, and meetings. (Annual Report, 1922, *Minutes of the Board of Trustees.*)

MISS ANNIE POWE HOPPER. In 1922, she was promoted to principal of the training school, and when Miss Gallaher had to go on family leave to care for a sick relative, Miss Hopper became acting dean of women. She assumed the post permanently in 1923 and enjoyed a long and illustrious career as dean at GSWC.

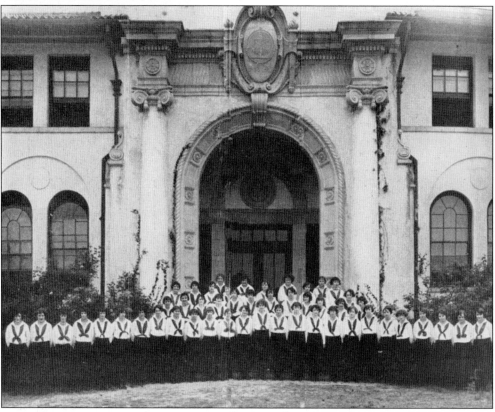

GRADUATING CLASS OF 1924. The class will of 1924 and other "documents" make clear that, though the school offered four-year degrees in 1924, most of these graduates were sophomores, receiving associate's degrees. Here is a prank played upon the graduates: "Pandemonium broke loose among the student-body . . . on May 17th, when it became known that the Freshmen and Juniors had found the Soph's [sic] and Seniors' caps and gowns." The usurpers proceeded to go through a mock class day graduation. (*Pinebranch*, Sophomore Issue, p. 27.)

A **1922 Photograph of Frances Dekle, Freshman, of Lowndes County.** She is "a very conscientious worker and extremely well loved as a practice teacher, she is noted for being the most modest girl in the school—and the most demure. We think she might decide to grace the teaching profession—for she's a shark in history—for a little while anyway. There's not a neater, sweeter maiden in the land." (*Pinecone*, 1925, p. 36.)

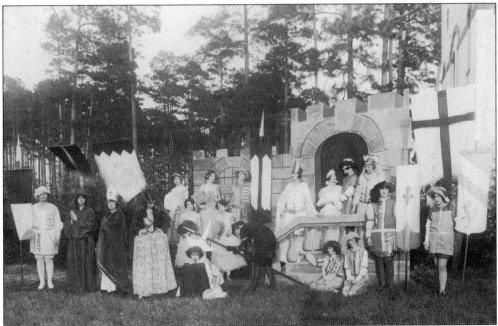

Love's Quandary: A Miniature Opera in Two Acts. "On Friday evening, February 20 [1925] . . . the Glee Club presented 'Love's Quandary,' a miniature opera" (*Pinebranch*, March 1925, p. 23). "[Members include] Sara Arnold, Erma Barco, Mary Chestnut, Alice Clarke, Marie Clarke, Rena Mae Campbell, Madeline Culbreth, Mildred Hicks, Harriet Jones, Rema Jones, Agnes King, Irma Mathis, Elizabeth McRee, Leo Prime, Clifford Quarterman, Olive Rogers, Marjorie Seals, Virginia Thomas, Martha Youngblood." (*Pinecone*, 1925, p. 81.)

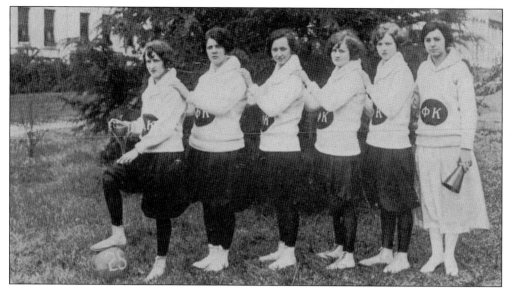

THE ATHLETIC ASSOCIATIONS: PHI KAPPA. Two competing groups provided the teams for intramural sports at GSWC. Pictured here is the six-person basketball team of the Phi Kappa's. However, almost every girl in the school belonged to one club or the other. The Phi Kappa cheer goes "I'm a Phi Kappa born/I'm a Phi Kappa bred/And when I die/I'll be a Phi Kappa dead/So it's Rah! Rah!/Kappa, Kappa . . . [etc]." (*Pinecone*, 1926.)

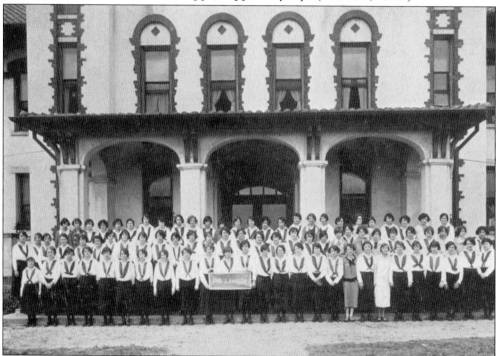

PHI LAMBDA GROUP PICTURE. Here is the approximate size of each athletic association. The groups sponsored tournaments and games in many different sports. The Lambda cheer goes "Cheer for the Lambdas/Lambdas to win/Fight to the finish/Never give in, Rah, Rah, Rah/You do your best, Girls/We'll do the rest, Girls/Lambdas will win today." (*Pinecone*, 1926.)

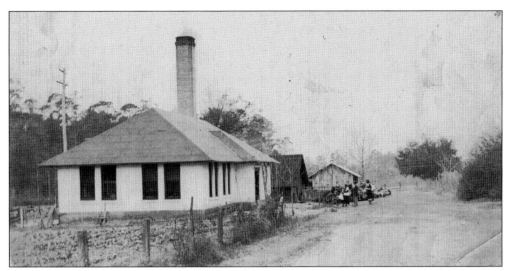

THE GYMNASIUM. "The building is only temporarily in use as a gymnasium. It will eventually be . . . a laundry. It is a brick building, solid and permanent . . . but very plain. Its main features are strength and light. It is equipped with several hundred dollars worth of modern gymnasium equipment." The building was hardly temporary. It served first as a gymnasium, later remodeled into the Rebel Room, then the Blazer Room. It was razed to make way for the college union addition in 1975. (*GSWC Bulletin*, 1923, p. 14.)

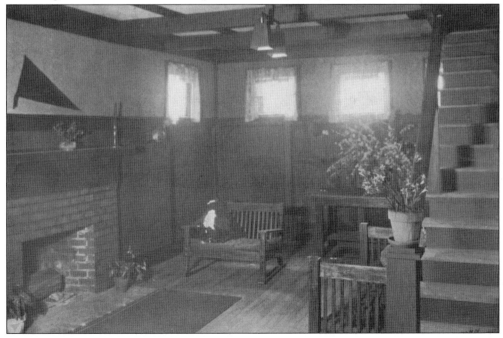

THE FIRST "HOUSE IN THE WOODS." The class of 1923 wanted "a place where the girls might spend their leisure hours, have their feasts, marshmallow toasts, steak fries and all sorts of jolly times. They decided to convert a shabby old shack in the woods into a bright, sunny little clubhouse. The work was begun by that class and with the help of the literary societies, the classes and the YWCA, their dreams of a cozy little clubhouse have at last become a reality." (*Pinebranch*, December 1924.)

EVERYDAY UNIFORM OF THE 1920s. In the later 1920s, the uniform was modernized and the rules, relaxed: "All students of the freshman and sophomore classes who live in the dormitories of the College are required to wear the uniform. Any other student of the College may or may not wear the uniform." (*GSWC Bulletin*, 1927–28, the Uniform.)

NEW WINTER DRESS UNIFORM. "The uniform of the College is the badge of the College . . . The College provides an exceptionally high type coat at an exceptionally low cost, so in the matter of the uniform, it provides for exceptionally beautiful, healthful, and serviceable clothing at exceptionally low cost . . . The one-piece dress of navy serge (worn in place of [crepe dress]) on cool days [is] $10.00." (*GSWC Bulletin*, 1927–28, the Uniform.)

MISS GSWC: EPPIE ROBERSON, AB EDUCATION, NAHUNTA, GEORGIA. "This, friends, is the Editor-in-Chief of the Pinecone . . . [She] has the knack of dipping her fingers into all the college pies; her very presence makes the venture successful. Eppie is the third charter member . . . having come to [GSWC] from the college high school. She is chiefly noted, however, for her ability to remain true to one love during her four college years." (*Pinecone*, 1925, p. 38.)

NANA ALEXANDER, VOTED "BEST ALL AROUND" IN **1925.** "Do you remember when we were freshmen, the little girl with that 'Age of Innocence' expression? Yes, that was Nana, and she still makes use of that expression—on occasion. . . . [She's] a mathematics shark, one of the athletic association presidents, and plays a good game of basketball. She's almost always hungry, and she is notorious as a man-hater. We think that her hatred is merely a pose, and she likes 'em just as well as we do." (*Pinecone*, 1925, p. 35.)

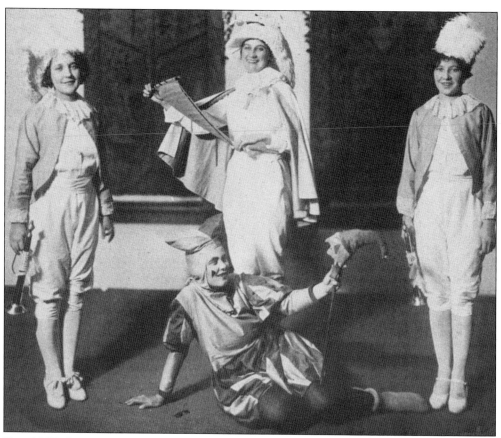

THE 1927 OLD ENGLISH CHRISTMAS FESTIVAL, GSWC. Tradition always dictated a Lord of Misrule, center back; two heralds, either side; and a fool to preside over the Old English Christmas Festival.

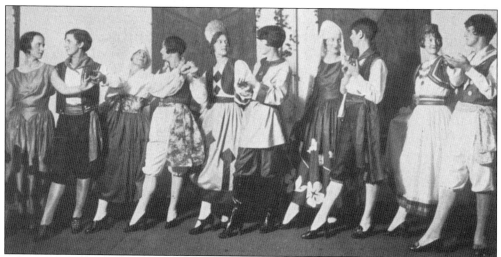

SOME 1927 CHRISTMAS FESTIVAL DANCERS. In between the Yule Log and the minuet, costumed skits and dances entertained those attending the Christmas Feast. This dance features dancers from a foreign land. (*Pinecone*, 1928.)

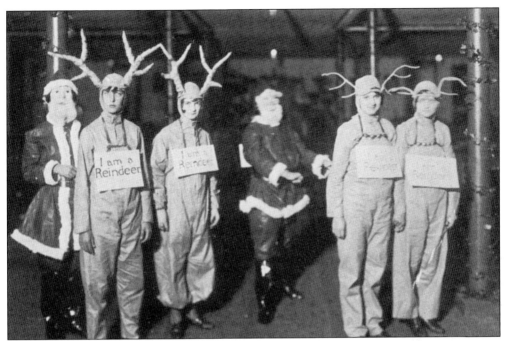

"I AM A REINDEER." This 1925 image shows the Christmas festival where Saint Nicholas often appeared.

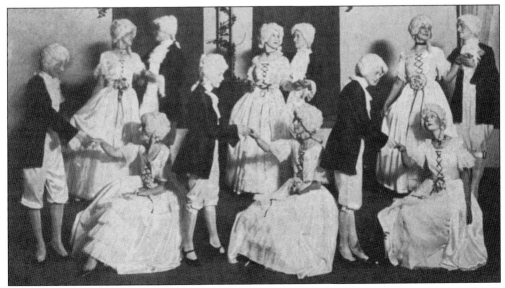

YE MINUET. "Caught with the spirit of joyful glee, the stately minuet is danced by the lords and ladies of the court." (*Pinebranch*, December 1928, p. 22.)

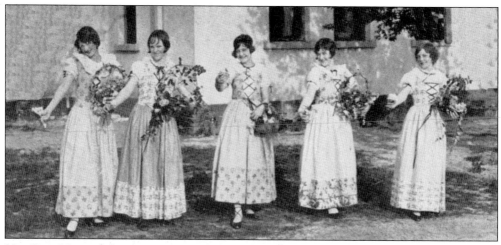

MAY DAY. "One of the most spectacular and colorful Old English May Day Festivals . . . at the College was . . . presented on May 1st by the department of physical education under the direction of Miss Leonora Ivey. About 250 people participated in the activities. The first scene, that of the Village Green on an Early May Morn, suggested the revels of the English before crowning the Queen. College girls as flower girls suggested the beauty of rural England." (*Pinebranch*, May 1928.)

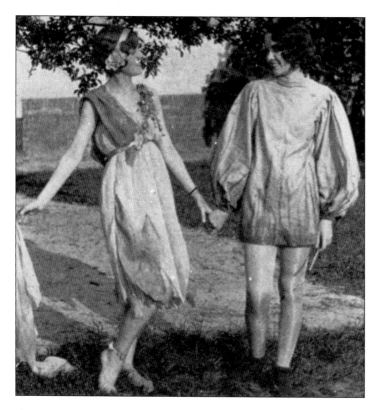

NYMPH AND SHEPERD. As part of the second entertainment for the May Queen, "Music Hath Charms" [was] danced by the Shepherd, Miss Juanita Sweat, of Waycross, and Miss Jean Loggins, of Valdosta, as the Nymph." (*Pinebranch*, May 1928, p. 28.)

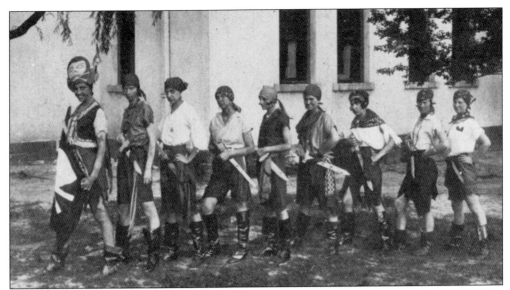

PIRATES, 1928 MAY DAY. "The Festivities in honor of the May Queen were delightfully colorful and entertaining . . . College girls [dressed] as bold bad pirates in the dance, 'Fools Gold'." (*Pinebranch*, May 1928, p. 28.)

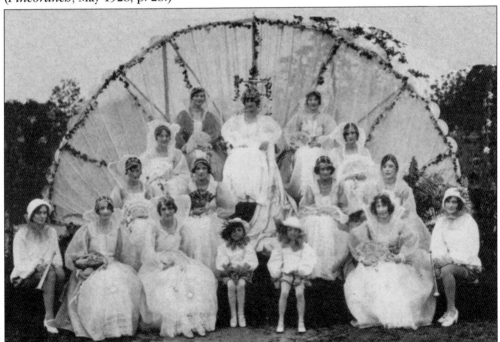

THE QUEEN AND HER COURT. "Shown are Train Bearers Julia Bess Smith and Margaret Miller (Valdosta); Heralds Eleanor Turner (Sylvania) and Mary Stokes (St. George); Ladies in Waiting Louise Holcome, Tennys Jones, and Catherine McRee (Valdosta), Sara Julia Cox (Vienna), Willie Belle Harrell (Whigham), Merle Johnson (Surrency), Blanche Prescott (Lake Park), Myrtle Stokes (Nahunta), Marie Parham (Nashville), and Willie Belle Sumner (Poulan); Maid of Honor Elizabeth McRee; and Queen of the May "Miss Katherine Blackshear of Sarasota, Fla., elected by the student body from the senior class." (*Pinebranch*, May 1928, p. 27–28.)

DISTINGUISHED SENIOR CAROLINE PARRISH, VOTED "CUTEST." She was the little girl breaking ground for West Hall . . . Now she's growing up: "Caroline, our cutest Senior, is not only cute. She has plenty of sense—not the kind stored away for future use, but the kind she uses now. Although Caroline is one of the most business-like students on the campus she is never too busy to be one of the most likeable." *(Pinecone*, 1930, p. 39.)

SOPHOMORE CLASS PLAY. The play entitled *Peg O' My Heart* was performed at the Ritz Theater, Valdosta, on Friday March 1, 1929. It starred Mrs. Louise Clyatt as Peg, "a poor girl living with her father in New York . . . was left an heiress by the death of her uncle . . . she [went] to England to live with a . . . proud haughty aunt. [Trouble follows until] she won her way and also Jerry." The actors included Elizabeth Cox, Margaret Brabham, Juanita Sweat, Lillian Hopper, Margaret Sumner, Dorothy Stovall, Virginia Fraser, and Jessie Mae Prescott. *(Pinebranch*, March 1929, p. 34–35.)

Three

THE DEPRESSION: 1929–1941

By the 1930s, life at GSWC centered around traditional activities: picnics at the fireplaces, plays, club activities, and afternoon tea in the Rotunda overseen by Miss Hopper. However, the establishment of a statewide board of regents in 1931 and the fiscal disasters common in 1932 led to a situation that shook the campus. In 1933, the board of regents declared the school a liberal arts college, eliminated the training school, and all but eliminated the department of education. These measures saved money, but some of the affected faculty "took to the streets" with petitions and complaints. When the dust cleared, a token education department remained, Dr. Powell, the president, was transferred to Athens to head the Coordinate College there, and Dr. Jere M. Pound came to Valdosta.

Because of ill health, Dr. Pound's tenure was short—by 1934, Dr. Frank Reade was acting president. A very visible sign of the New Deal–era was all the construction on campus. Senior Hall was built by the WPA. The pool, begun by the WPA, was finished by the state in 1938. The WPA built the House-in-the-Woods log cabin and the library. Because of personal friendship between the Reade family and the Roosevelts, First Lady Eleanor Roosevelt came to GSWC to dedicate the new library.

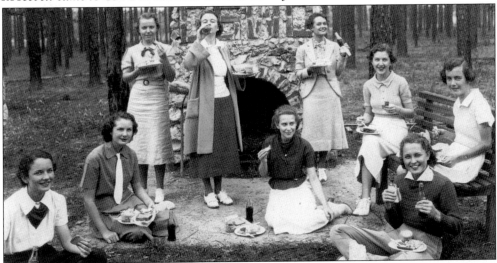

A CASUAL COOKOUT AT THE FIREPLACE. "The massive grey stone fireplaces, located on opposite sides of the campus, are favorite spots for steak suppers and wiener roasts." (*GSWC Bulletin*, 25th Anniversary, 1938, p. 14.) The fireplaces were donated by "thoughtful faculty members for making our campus life more interesting, and credit is due to Miss Ivey, Miss Gilmer, Mr. Dusenbury, and Dr. Powell for our added pleasures." (*Pinebranch*, Nov. 1931, p. 15.)

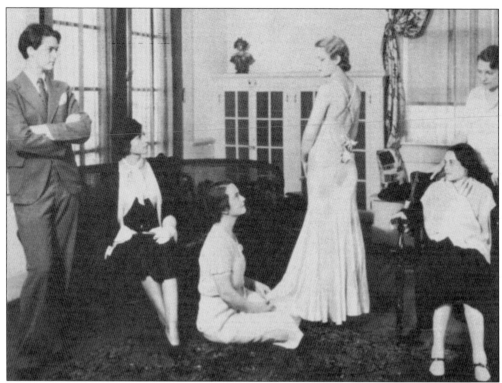

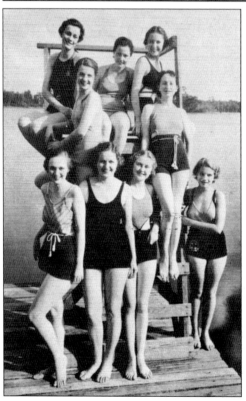

THE SOCK AND BUSKIN CLUB'S PLAY, *HAPPINESS*.
The Sock and Buskin Club is a dramatic
club that includes "only the more gifted
players of the College." (*Pinecone*,
1933.) "Here is the Sock and Buskin's
annual play . . . [presented in 1932] at
the Ritz Theatre. The characters and
players were Philip Chandos—Willene
Roberts; Fermoy McDonagh—Lillian
Lively; John Snowcraft— Louisa Heeth;
Mrs. Crystal-Pole—Elizabeth Kirkland;
Miss Perkins—Ruth Dozier; Mrs. Wreay—
Frances Howell; Jenny Wreay, who scatters
happiness around her—Louise McMichael."
(*Pinebranch*, May 1932, p. 19.)

SWIMMING AT TWIN LAKES. Before the pool
was built in 1938, Twin Lakes, south of
Valdosta, was a favorite swimming venue
for the campus. In 1935, the horse riding
group and their teacher, Mr. Sam Langston,
rode there for lunch; the Math Science
Club had its annual picnic at the lakes; and
Misses Leonora Ivey and Elizabeth McRee
took the Athletic Council to an "out-door
supper at Twin Lakes." (*Campus Canopy*,
5/15/35 and 5/29/35.)

AFTERNOON TEA IN THE ROTUNDA.
Students at GSWC dressed
formally and attended teas or
receptions in the rotunda of
Ashley Hall. In 1936, formal
events included an annual faculty
reception, an exhibition of
"moving pictures of 'the glory that
was Greece,' "and a forum on the
work of Cornelia Otis Skinner.
(*Campus Canopy*, 1936.) Formal
afternoon teas were common, and
Miss Annie Powe Hopper insisted
that the girls know the etiquette to
properly participate.

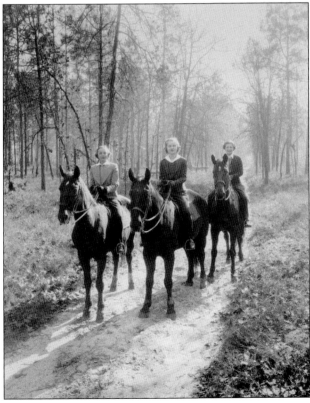

HORSEBACK RIDING ON CAMPUS.
"Miles of Lovely Bridle Paths
Wind Through the Pines
Around the College." (*Campus
Glimpses*, 1937.) "Horseback
riding, under the direction of
[Mr. Sam Langston], is offered
at modest price." (*GSWC
Bulletin*, 1935, p. 14.) Plans
for the program include setting
up "a ring on the campus,
and have a horse show, with
running and jumping. The best
rider will be awarded. There
will be a riding course through
the woods." (*Campus Canopy*,
5/29/35, p. 5.)

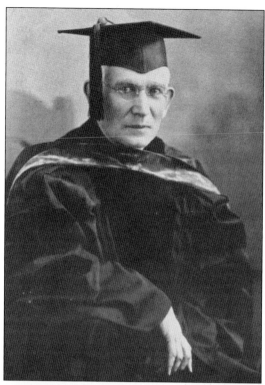

DR. POWELL AND THE BOARD OF REGENTS. Prior to 1931, a board of trustees had governed the college, but in 1933, all schools in the university system came under a "board of regents." After a study of the system, the board of regents and the chancellor declared "GSWC should become the liberal arts college for women . . . and . . . the training school should be discontinued." (Hambrick, *Valdosta State College: The First Half Century*, p. 29.) At the same time a statewide financial crisis mandated deep cuts in salaries and expenses. Education was retained as a depleted major, but the training school and six faculty were lost.

TRAINING SCHOOL—CLOSED IN 1933. Several of the faculty, mainly the head of the training school, tried to change the board's decision. The situation deteriorated: "Petitions are being circulated . . .[a] lawyer has been employed to gather personal slander about me . . . I have kept in touch with [the regents] by telephone, and we agree that it is the better policy for us to just sit steady and let the talk blow over." (Dr. Powell, letter to Hughes Spalding, 3/31/33.) But it did not. The board did close the training school and also directed that Dr. Powell be moved to Athens to head the Coordinate College at University of Georgia.

Dr Jere M. Pound, Second President, 1933–1934. Dr. Pound, an old friend of Dr. Powell's, assumed the presidency of GSWC on July 1, 1933. A Georgian, he received A.B. and L.L.D. degrees from University of Georgia. He had been a teacher, principal, superintendent of public schools, state superintendent of schools, and director of what later became GSCW in Milledgeville. In 1912, he became president of Georgia's State Normal College in Athens. His health only allowed him to work for one year, and he was placed on sick leave in 1934 and died in February of 1935.

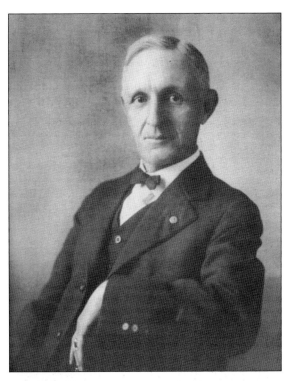

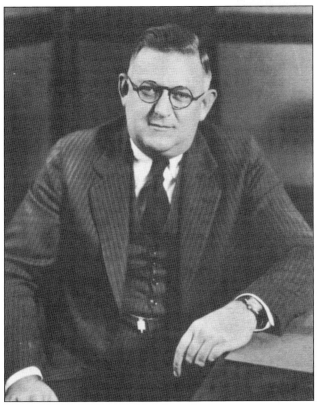

Dr. Frank R. Reade, Third President, 1934–1948. Dr. Frank Robertson Reade came from Athens in 1934 as "executive dean-elect" and assumed the presidency at Dr. Pound's death. Reade, from Abingdon Virginia, received A.B., M.A., and Ph.D. degrees from University of Virginia. He had been a teacher, an editorial writer at the *Atlanta Constitution*, a professor, and an administrator at Georgia Tech. Dr. Reade "brought to the college the outlook and attitudes of a typical conservative Episcopalian, and Virginia gentleman, plus a keen sense of humor, a love of sports, and an outgoing personality which invited the confidence of student and faculty alike." (*Campus Canopy*, 5/6/68, p. 5.)

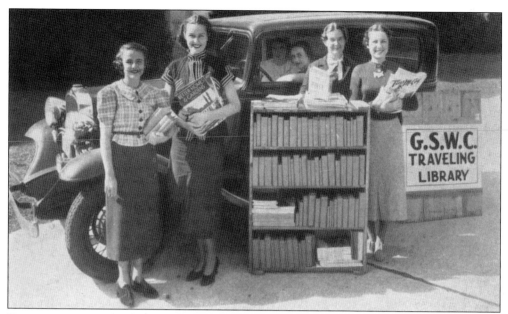

NATIONAL YOUTH ADMINISTRATION TRAVELING LIBRARY PROJECT. "The College, through the Traveling Library is attempting to provide adequate library service to the rural communities of Lowndes County." (*GSWC Bulletin,* 25th Anniversary, 1938, p. 23.) This joint project involved the college library staff, the National Youth Administration Program, and the Works Progress Administration. "Those accompanying the Rolling Library on . . . [its first trip] from GSWC were Pauline Brewster, Kathryn Toole, Jewel Mullinax, Miss Lillian Patterson, Miss Evelyn Deariso, and Miss Thyrza Perry." (*Campus Canopy,* 10/30/36, p. 4.)

A STUDENT VOLUNTEER FROM THE SOCIAL SERVICE INSTITUTE. "Increased interest in the social sciences stimulated by the disastrous experiences of the 'depression years' led the college . . . to add faculty and courses . . . for training in social work." The college, "in cooperation with the State Department of Public Welfare and with the Lowndes County Department of Public Welfare, gave a training institute for . . . students who . . . became eligible for positions with the . . . departments of public welfare." (*GSWC Bulletin*, 25th Anniversary, 1938, p. 24.)

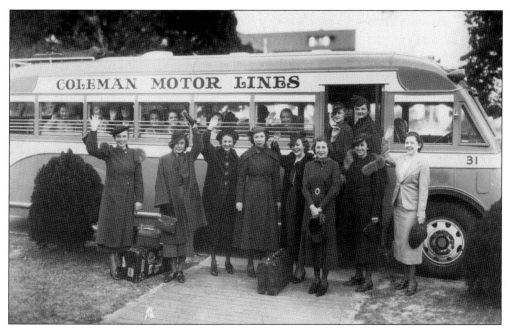

SENIOR ANNUAL TRIP TO NEW ORLEANS. "Calling all cars . . . Tallahassee, Mobile, New Orleans . . . and the seniors had arrived! Leaving the college at 8 pm last Wednesday they reached the Roosevelt Hotel in New Orleans at noon Thursday after traveling all night. Reports have it that they saw the town right—from night clubs to cemeteries." (*Campus Canopy*, 3/12/37.)

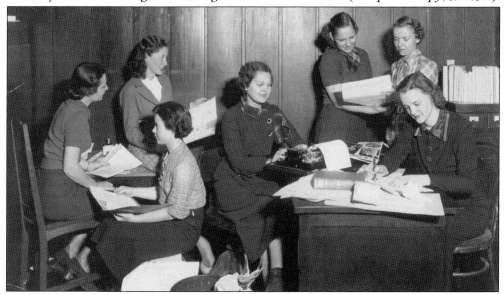

THE CANOPY STAFF. The monthly magazine *Pinebranch* gave way to the sometimes weekly newspaper *Campus Canopy* in 1934, and by 1937, "For the first time since a student paper has been established on the campus *THE CAMPUS CANOPY* has followed a regular schedule of publication, being distributed . . . each Friday. The paper is a four-column, four-page weekly publication. . . . This year, the Editor was Lorene Johnson; Business Manager, Katherine Moore; Assistant Editor, Rosalind Lane; and the Advertising Manager was Carolyn Greene." (*Pinecone*, 1937.)

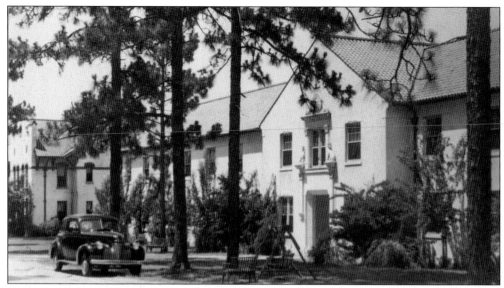

SENIOR HALL. "In the early spring of 1937, a new dormitory-auditorium building, erected with State funds and the Public Works Administration at a cost of $60,000.00, was completed. About $7,000 has been spent to equip the 28 bedrooms with maple furniture." (*GSWC Bulletin*, 1937–38, p. 13.) The building "contain[s] a reception room, a room for over-night guests, an alumnae reception room and a lounging room for day students. The remaining first floor [also has] a recreation room for the class dances, games, and parties." (*Campus Canopy*, 8/6/36.)

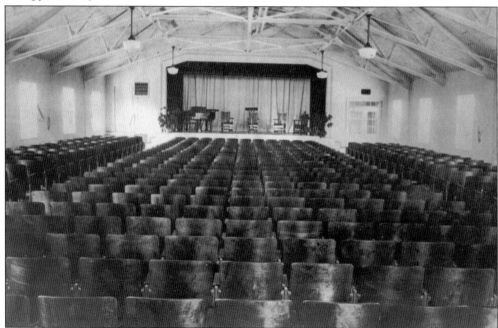

THE AUDITORIUM (LATER READE HALL) IN THE DORMITORY. "The entire south half of the second floor will be devoted to the new auditorium. The auditorium, which will have a seating capacity of five hundred, will have a completely equipped stage for performances . . . It also includes a Steinway piano." (*Campus Canopy*, 8/6/36.)

50

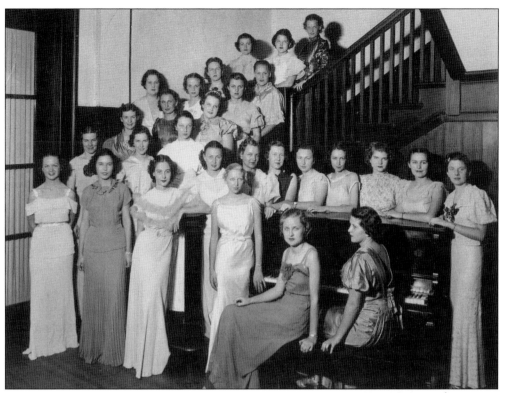

THE GLEE CLUB OF 1937. Members of the 1937 glee club were, alphabetically, Carolyn Askew, Geraldine Butler, Margaret Carter, Montine Cowart, Madeline Douglas, Branch Ellis, Helen Fletcher, Virginia Giddens, Sue Nelle Greenlee, Pardee Greer, Lota Griffith, Mary Johnson, Idelle Lee, Daisy McNeal, Jonelle Marchant, Eleanor Morgan, Marie Porter, Sara Martha Pyle, Juanita Simmons, Louise Stump, Lerah Sutton, Rosalind Taylor, Evelyn Tomlinson, Katherine Toole, Margaret Wade, Ruth Williams, and Emily Wootten. (*Pinecone,* 1937.)

THE SILVER ANNIVERSARY 1938. Distinguished guests attending the silver anniversary exercises for Georgia State Womans College on January 15, 1938, included, from left to right, Chancellor S.V. Sanford, Architect W.A. Edwards; and board of regents members Cason Callaway of LaGrange, George Hains of Augusta, and Miller S. Bell of Milledgeville. (VSU Archives Photograph Collection.)

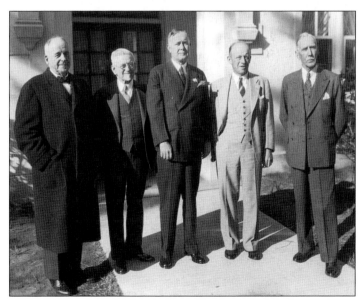

51

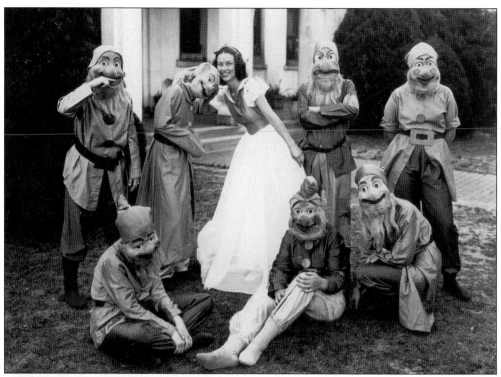

SNOW WHITE EMBRACING DOPEY.
During the 1938 May Day, the
story of Snow White provided a
frame for all of the dance skits.
Here is Snow White and the
seven dwarfs. Dorothy Brown
played Sneezy; Louise Blanks
was Dopey; Opal Brown was
Snow White; Frances Giddens
played Grumpy; Elizabeth
Borders was Doc; Marigene
Stringer played Bashful; Marion
Orr was Happy; and Sleepy was
played by Emily Cumming. (VSU
Photograph Collection.)

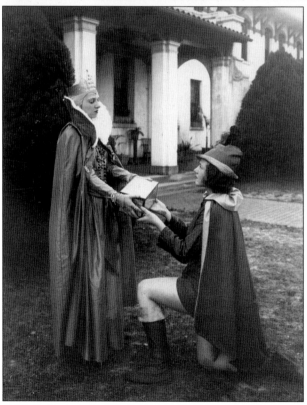

**MAY DAY PRODUCTION OF SNOW
WHITE: THE WICKED QUEEN.**
Mary Catherine Abernathy, the
wicked Queen, gives a message
to the Huntsman, Curtis
Whatley, on May Day, 1938.
(*Pinecone,* 1939.)

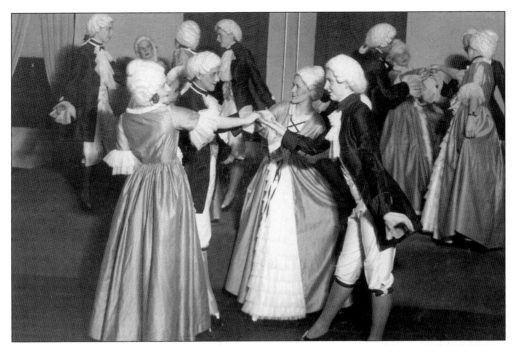

DANCING THE MINUET AT THE CHRISTMAS FESTIVAL. The minuet was an integral part of the Christmas celebration: "Christmas season really begins when the chorus classes start practicing . . . The dancing classes have extra sessions at night to learn new steps . . . The Glee Club [chooses carols to sing when] they march through the halls at dawn on the day of the Festival . . . Everything is moving [toward] . . . Ye Olde English Christmas Feaste . . . [held] the last day before we go home for Christmas." (*Pinebranch*, December 1931, p. 19.)

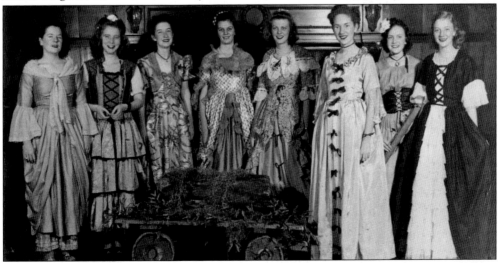

THE GLEE CLUB BRINGS IN THE TRADITIONAL YULE LOG. "The first event of the traditional Christmas festival was a Yule Log procession into the banquet hall. Here are members of the Glee Club in costume for the 1939 Christmas Festival." (*Pinecone,* 1940 and *Campus Canopy*, 12/8/39.) According to an earlier account, "After the guests have assembled, the Yule Log is brought into the great hall by a group of merry singers." (*Pinebranch*, December 1932, p. 4.)

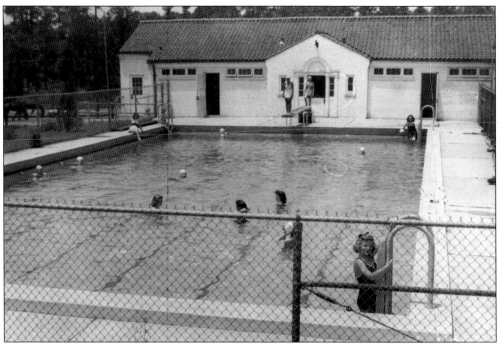

The Pool. The swimming pool was almost not built. In 1936, authorization for the pool was approved and sent to the Works Progress Administration, where the plans were drafted. However, before it could be built, the WPA in Lowndes County "dropped from 900 [employees] to less than a score and . . . [the] project [could not] be carried forward." The state completed the pool for $25,000, and it opened in May 1938. (*GSWC Bulletin*, 25th Anniversary, 1938.)

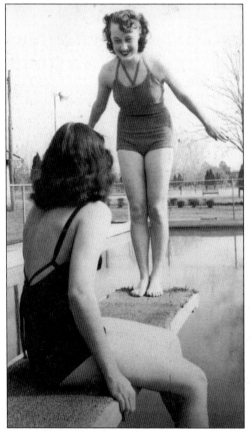

Girls Do a Back Dive. "The pool is standard collegiate size, thirty-five by seventy-five feet, and is equipped with purification plant, re-circulation system, diving board, ladders, and both overhead and underwater lighting. Bath house equipment includes steam heat, hot and cold showers, dressing rooms, lockers, foot-baths, hair-dryers, and a laundry." (*GSWC Bulletin*, 1939, p. 14.)

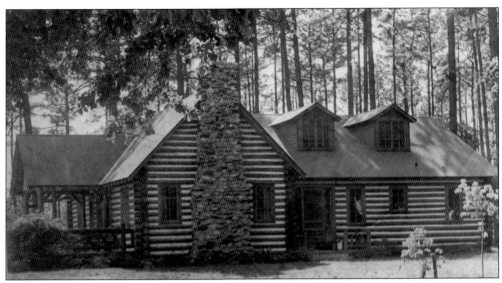

HOUSE IN THE WOODS. "On May 6, 1939, a Student Activities Log Cabin was officially dedicated. The building was erected and furnished as a Works Progress Administration project at a total cost of about $9,000.00." (*GSWC Bulletin*, 1940–41, p. 13.) The student groups raised $850 to furnish the building. It had offices for the *Campus Canopy*, the *Pinecone*, and shared offices for the YWCA and the SGA. This log cabin was built on the site of the old "House in the Woods," begun by the class of 1923.

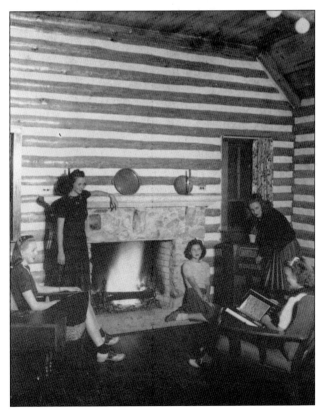

THE CARNEGIE MUSIC SET. "The main room in the house is the general assembly room . . . [with] two fireplaces, . . . game tables, piano and radio." (*Campus Canopy*, 5/5/39, p. 1.) Here, the girls are enjoying the Carnegie music collection: "The Carnegie Corporation has given us a library of 600 record discs, and a Lyon and Healy record player and amplifier. It is also in the Log Cabin, the best music of the world available to any of us whenever we wish to hear it." (*Campus Glimpses*, 1940.)

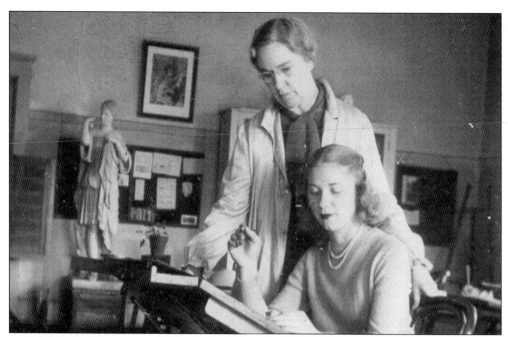

FINE ARTS AT GSWC. Miss Frances Ruth Carpenter, an art professor, advises Louie Peeples, president of the fine arts club, on her drawing. "They are the artists of the campus, the twenty-five Fine Arts Club members. They give art its place in college and create an art-consciousness among the students. The club was responsible for numerous exhibits . . . they sponsored speakers, a Saturday Morning Sketching Class and a craft shop. The club held a Christmas Bazaar and traveled . . . to see the Ringling Art Collection." (*Pinecone*, 1940.)

JEANNE PRYOR AND JACQUELINE SMITH READING MAGAZINES. "Socially quiet, but scholastically the biggest noise on campus, the Freshman Honor Society is composed of the cream of Sophomore intelligentsia who have passed through their Freshman year with honors . . . For everyone's reading pleasure, the club donated subscriptions to four popular magazines and placed them in the House in the Woods." (*Pinecone*, 1941.)

56

THE LIBRARY (POWELL HALL). The centerpiece of WPA construction on campus was the "new $72,000 library at GSWC resting among the tall, stately pine trees on [the] north side of the campus." (*Campus Canopy*, 3/29/41, p. 1.) According to a description, "the library [is the] newest building on the campus, with the Mediterranean influence of the campus carried out in its design. Thousands of volumes of carefully chosen books, magazines, and periodicals are here for our study or leisure-time use." (*Campus Glimpses*, 1940.)

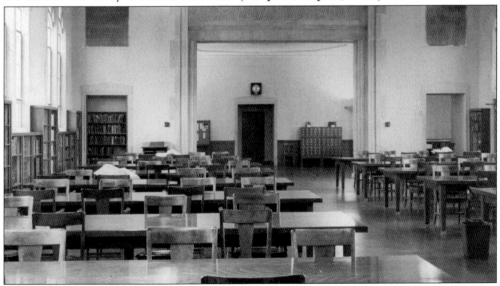

THE READING ROOM OF POWELL HALL LIBRARY. "A wide open archway on one side leads into the main reading room . . . In spite of the height of the ceiling of the reading room, there is no echo, the room having been so constructed that the acoustics are almost perfect. Shelves of reference books line the walls of the room . . . GSWC now has one of the finest libraries of any college in the South." (*The Alumni News*, 4/10/41.)

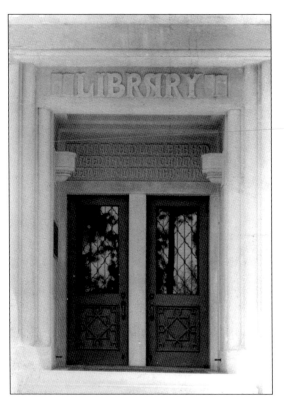

THE ENTRANCE TO THE NEWLY BUILT LIBRARY. In the main entrance to the library the quotation from Sir Frances Bacon reads: "If a man read little, he had need have much cunning to seem to know that he doth not." (Library Papers Collection.)

ELEANOR ROOSEVELT WITH DIGNITARIES. Since Mrs. Roosevelt's father and Dr. Reade's father were friends, he asked her to come to Valdosta and dedicate the new library. The first lady stayed with the Reades and dined with the students. "Dignitaries from all over Georgia attended, and 5,000 heard her speech: 'In this building you are given an opportunity to study and prepare yourselves for the future . . . I dedicate this building to interesting youth and the strange world in which you live.' " (*Campus Canopy*, 3/29/41, p. 1.)

58

Four

THE WAR YEARS: 1941–1950

During most of 1941, life at GSWC continued as it had in the 1930s. Club activities, festivals, sports competitions, and visiting dignitaries from the ongoing artist series were the center of campus life. But that came to an abrupt halt after Pearl Harbor. GSWC mobilized for war. The students started a War Bond campaign to buy "planes, ships, tanks, and guns" and to provide scholarships for future students. Emory Junior College closed temporarily, and a few young men from Valdosta attended GSWC. The GSWC students did their part through scrap drives and Red Cross work. Curriculum changed to include "defense courses." Although traditional festivals were cancelled "for the duration," GSWC social life didn't suffer. Moody Airfield north of Valdosta provided the men for dances and dates, and the girls supported morale with USO parties.

After the war, tradition re-asserted itself. Christmas Fest and May Day reappeared in most of their former glory. The young men went back to Emory Junior College, and college life seemed to go on much as before. But in 1948 ill health forced President Reade to take a year's leave of absence, and Dr. Ralph Thaxton, from University of Georgia, served as acting president in 1948–49. After Reade's retirement, Thaxton served as president from 1949–1966. This change in leadership presaged a more radical change in the nature of the college: in January of 1950, the board of regents voted to change GSWC to a co-ed institution and rename it Valdosta State College.

THE 1941 YWCA FIRE LIGHTING SERVICE. The Fire-lighting Service, "held in the Rotunda of Ashley Hall, each year [in late October or early November, usually] marks the first lighting of the fires in the Rotunda, and symbolizes the kindling of the fires of friendship in the hearts of all GSWC Girls." (*Campus Canopy*, 10/30/48.) This tradition was sponsored by the YWCA and featured the presidents of all the campus clubs lighting the fires together.

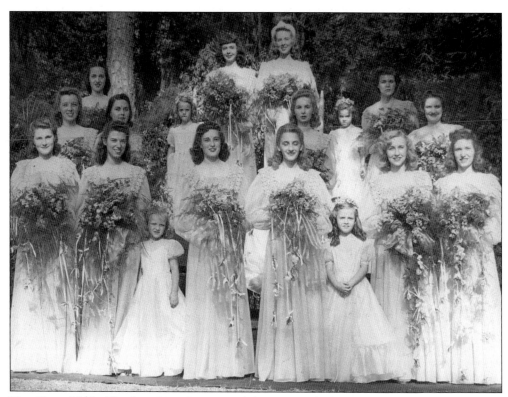

MAY DAY, 1942. The last May Queen and her court, before wartime cancellations, are pictured here. "Miss Virginia Power, of Vienna, reigned at the annual May Day Festival . . . Maid of Honor [was] Miss Nancy Cole, of Savannah. Front Row, L-R: Minnie Roberts, Alice Wisenbaker, Josephine Bogle, Edith Allen, Rachel Crittenden, Anne Ware, Dorothy Wilkes, and Julia Bess Smith. Second Row: Leecy Anne Henry, Maxwell Williams, Betty Franklin, and Mildred Mallory. Third Row: Marie Ambos, Suzanne Medow and Kay Fleming, Train bearers; and Mary Jean Rockwell. Top Row: Nancy Cole and Virginia Power." (VSU Photograph Collection.)

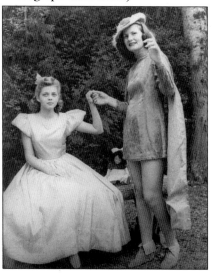

MAY DAY, 1942. After the 1942 event, May Day celebrations were cancelled "for the duration." "Off to the land of dreams with her Fairy Prince is Martha Lindsay [left], of Thomaston, who is pictured with Elizabeth Paschal [right], of Albany, at the May Day Festival presented at the Georgia State Womans College in Valdosta on . . . [May 1, 1942. They] danced leading roles in the May Day Ballet, 'King Nutcracker' based on the music of Tschaikowsky's (sic) famous 'Nutcracker Suite' arranged for chorus, ballet, and string ensemble." (VSU Photograph Collection.)

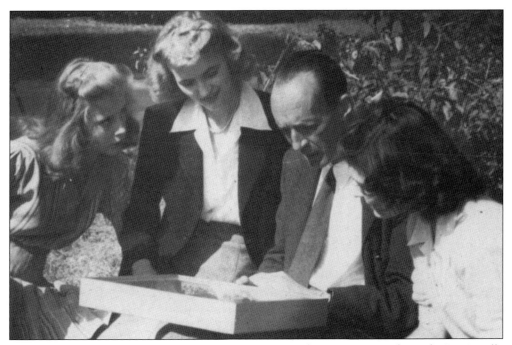

THE INTERNATIONAL ARTISTS SERIES—VLADIMIR NABOKOV. The artists series brought "nationally known artists,—speakers, musicians, and the like . . . [to] enhance. . . . the cultural atmosphere of the college and the community." (*GSWC Bulletin*, 1943–44.) The future author of *Lolita* came to Valdosta to GSWC in mid-October 1942. He spoke to many groups on literature and often mentioned his interest: " 'Entomology is a hobby of mine' he told students [of the Math and Science Club.]" (*Campus Canopy, 10/16/42.*)

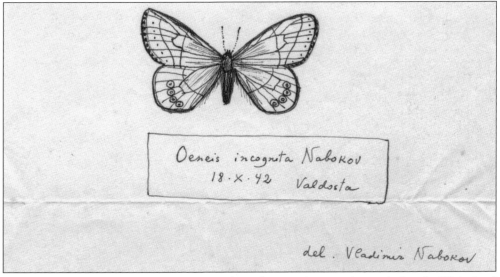

NABOKOV'S BUTTERFLY. Mrs. Reade: "I remember when we drove in the yard when he [Nabokov] came to lunch with us, a big swarm of yellow butterflies flew up out of the grass, . . . Nabokov hardly waited until the car stopped. He grabbed his net and was off, flying after them . . . Later while he and Frank were having a cup of coffee he sketched off an unusual butterfly he had found, signed his name to it and gave it to me." (*VSC News Bureau*, #340.)

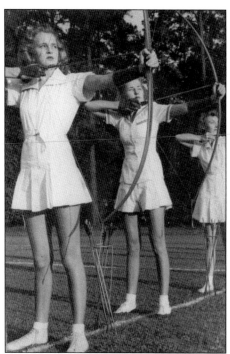

ARCHERY AT GSWC. "Aiming for the bull's eye are, left to right, Emily and Barbara Dekle of Cordele, and Mary Frances Donaldson, of Attapulgus" (*Campus Canopy,* 4/12/43.) "Archery, the sportsman's game, requires a lot of skill and we have the people here on campus who can teach you to become proficient . . . The P.E. Dept. will furnish all equipment, which incidentally, includes bows, arrows, gloves, targets, and COACHES!!! We'll have lots of archery tournaments for beginners as well as for qualified archers." (*Campus Canopy,* 10/2/43.)

THE INTERNATIONAL RELATIONS CLUB IN 1942. "America's entry into the Second World War gave members of the IRC a stellar opportunity for studying the effects of war and peace." Here are officers Helen Davis, member at large; Williard Parrish, vice president; Betty Franklin, treasurer; and Elizabeth Fender, secretary. (Ruth Sessions, president, is not pictured.) (*Pinecone,* 1942, p. 68.)

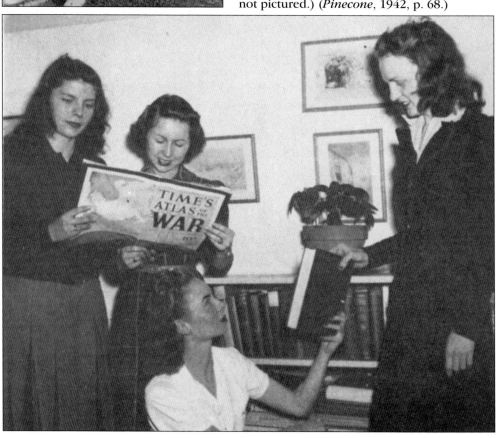

War Bond Scholarship Campaign Committee. In addition to raising money to buy bonds for "the immediate purchase of planes, ships, tanks, and guns," the War Bond campaign at GSWC established "a Loan Fund for students who, after the war, will need financial assistance to enable them to attend college." (*War Bonds Campaign Pamphlet*, 1941.) The scholarship committee is pictured here and are identified, from left to right, as Eleanor Cook, Amanda Key Waters, Corinne Smith, Harold H. Punke (faculty advisor), Mary Wilkie, and Mary Jean Rockwell.

Mrs. Roosevelt and Sara Catherine Martin, President of SGA, 1942–43. "I think the building of a War Bond Scholarship at the Georgia State Womans College is a grand idea, and your committee is certainly to be congratulated on the fine work it is doing in this worthwhile activity. I wish you every success." (The Students of GSWC Announce, . . . *Pamphlet*, 1942.) (The image was taken in March of 1941, when Mrs. Roosevelt dedicated the library.)

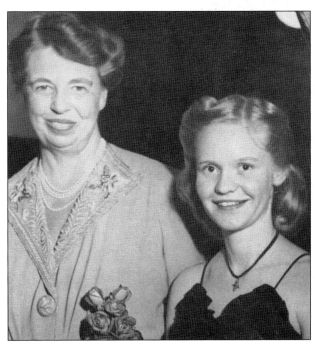

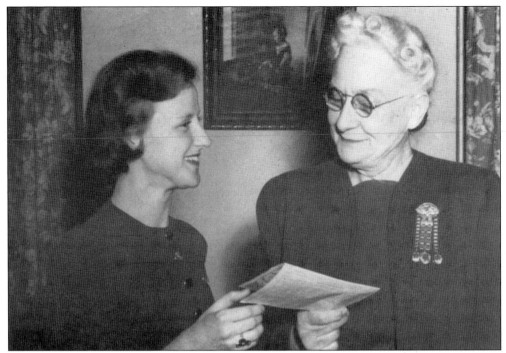

A War Bond Scholarship Campaign. The campaign was begun to help win the war and insure the peace that will follow. Miss Annie P. Hopper, dean of women at GSWC, presents the first War Bond to Miss Eleanor Cook of Savannah, student chairman of the campaign. (The Students of GSWC Announce, . . . *Pamphlet*, 1942.)

War Bonds from the Alumnae Chapter. Miss Virginia Culpepper, daughter of Mrs. William Culpepper (Virginia Hutchinson, 1934) presents a War Bond from the Valdosta Alumnae Chapter to Dr. Frank R. Reade. "I think that no group of students anywhere in our country has initiated so unselfish a campaign as this . . . Students, faculty, alumnae, and friends of this College are to be congratulated upon the splendid contribution they are making both to the Present and the Future." (Frank Reade, The Students of GSWC Announce, . . . *Pamphlet*, 1942.)

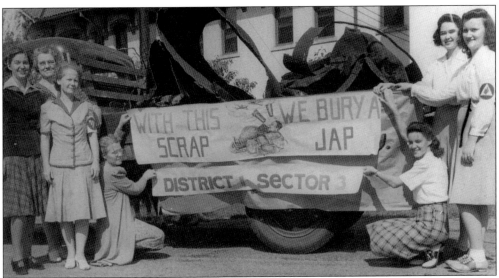

THE GSWC SCRAP DRIVE, OCTOBER 5, 1942. "County-wide scrap drive sponsored by civilian defense to aid war effort. L-R, Miss Anna Richter, Mrs. Eva Shrivalle, assistant sector wardens; Miss Lillian Patterson [GSWC Librarian], sector warden; Miss Beatrice Nevins, assistant sector warden; Misses Alice Gorden, Jean Williams and Elizabeth Gillis, fire watchers." (VSU Photograph Collection.)

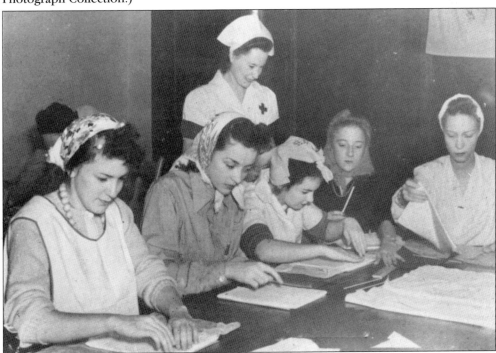

HELPING THE RED CROSS. "Students lend a helping hand to Red Cross" (*Pinecone*, 1943.) "The requirements for folding bandages at the Red Cross are: wear cotton, carry a bandana to cover hair, wear fresh nail polish or none at all, and of course a little sacrificing time . . . every time you fold a bandage you're hanging up one more star for American life and victory." (*Campus Canopy*, 11/19/43.)

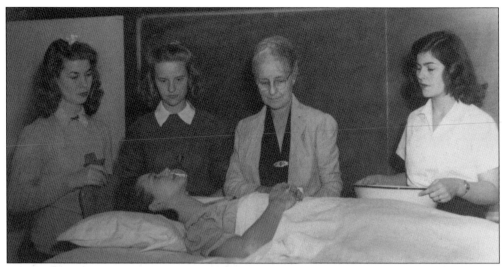

HOME NURSING COURSE. "Girls with visions of Florence Nightingale dancing in their heads have pounced with joy upon the home nursing course." Dr. Marian Farber, the GSWC resident physician, offers a course in "practical nursing that will be valuable not only in war time, but in the home." (*Campus Canopy, 1/16/42.*)

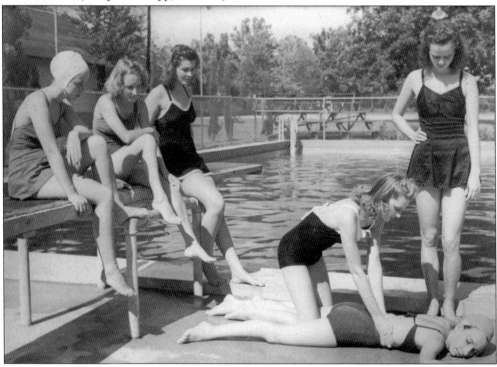

WATER RESCUE CLASS. "Putting knowledge into practice . . ." In addition to basic swimming, the school added a course in life saving during the war years. It taught, "American Red Cross methods of prevention of water accidents and care of victims." (*GSWC Bulletin*, 1943–44.) "Here Emily Dekle, Cordele, 'revives' Marion Posey, Valdosta, while Alice Meadors, Albany (right), Betty MaJette, of Jessup, Ruth Jinks, of Colquitt, and Jean Whittendale, of Norman Park, look on." (*Campus Canopy, 4/12/43*, p. 5.)

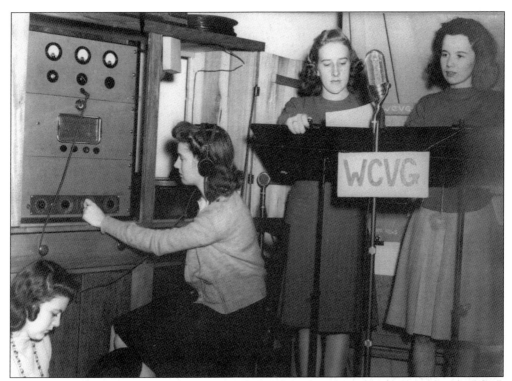

THE RADIO. "Julia Frances McCorkle, Elizabeth Jones, Mary Carol Allen and Betty Jane Dorough are pictured during an actual broadcast over the campus station W.C.V.G." (*Campus Canopy, 4/10/43.*) An apprenticeship in "radio managementæ is a part of the defense courses offered at GSWC during wartime.

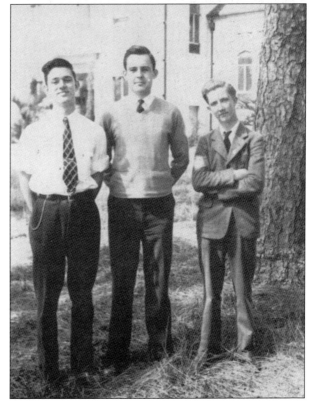

THE CO-EDS: JULIAN WILSON, LEWIS HOLDER, AND HUBERT ALEXANDER (*PINECONE*, **1945.**) "This fall for the first time in its history, the GSWC is admitting men as students at the regular sessions. This is an emergency measure brought about by the war and the subsequent moving of Emory at Valdosta to the Atlanta campus of the University. Only men living in Valdosta will be permitted to enter the college for study." (*Campus Canopy, 9/21/42,* p. 1.)

MISS ANNIE POWE HOPPER. The 1943 yearbook dedication reads: "With all respect due Miss Annie Hopper, Georgia State Womans College beloved Dean of Woman, who counsels and directs the lives of the students as efficiently as one of the U.S.A.'s four generals directs the men under his command, we dedicate the *Pinecone*, 1943." Miss Hopper retired at the end of the 1943 school year and went to live with her brother in Mississippi. She died in 1952.

THE DATE BOOK. The "Date Book" was used at GSWC during the early 1940s. The rules for freshman dating during war years were "A. Freshmen may have one date a week. B. Freshmen may not have dates with local boys the first quarter except with Emory Junior boys. C. All dates must be on the campus unless there is specific permission from parents. D. Dates must be in parlors, in the Recreation Hall except on Sunday nights, or in the Log Cabin . . ." (*Student Handbook*, 1943–1944.)

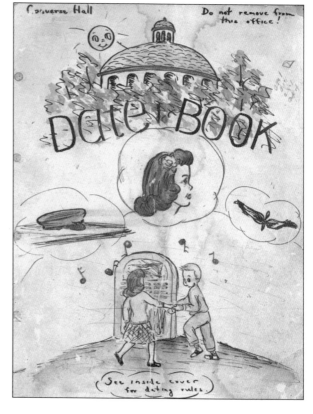

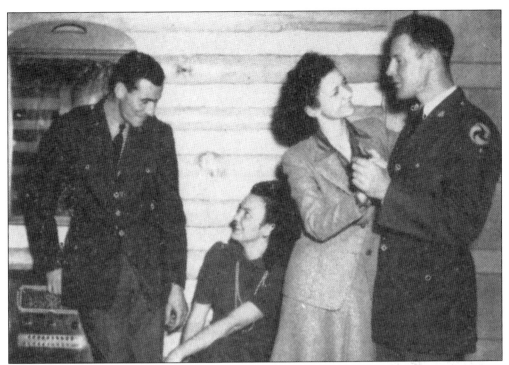

"Keep 'em Flying, Girls!" (*Pinecone*, **1942.**) "Jackie McCrary, Waycross, and Harriet Flournoy, Fort Valley, entertain Moody Field boys at the House-in-the-Woods." (*Campus Canopy*, 4/12/43.)

Catherine Garbutt, Sophomore Class President, 1943. "Because of expensive costumes and the difficulty of transportation, . . . festivals like Mayday or Christmas Feaste have been discontinued for the duration . . . We don't have our formals now . . . But there are still the Saturday night dances, and fun is had by all. (*Campus Canopy*, 10/2/43, p. 5.)

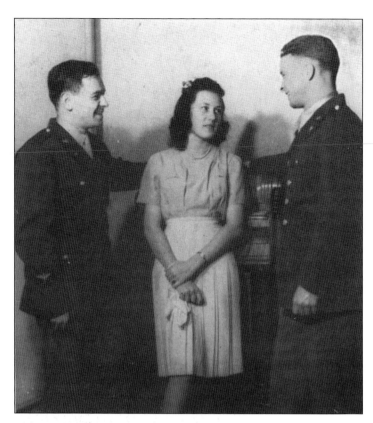

BETTY COLLINS, 1943. Saturday night dances at the Recreation Hall "provide the girls with entertainment (and men) . . . For off -campus activities, there are the Cadet Dances on Wednesday night at Moody Field, and the U.S.O. dances on Saturday night at the U.S.O. center." (*Campus Canopy,* 4/12/43, p. 3.)

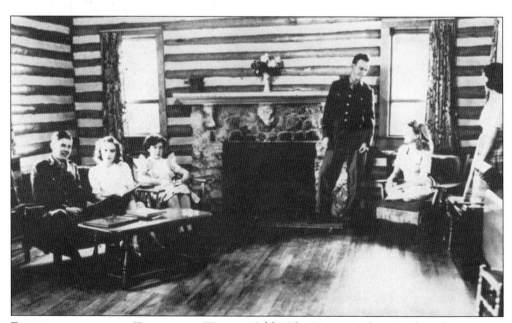

ENTERTAINING INSIDE THE HOUSE-IN-THE-WOODS, 1944. "The House-in-the-Woods is always open to anyone wishing to cook supper, or maybe waffles for Sunday morning breakfast—Yum-m-m-m! Or maybe just to 'date' on Sunday night." (*Campus Canopy, 4/12/43.*)

AFTER THE WAR. This is a candid snap of members of the 1946 junior class. After the war, Emory Junior College re-opened, the men left, and life retuned to "normal." (*Pinecone,* 1946.)

THE CAMELLIA TRAIL. "For a long time Dr. Reade has planned and hoped that the campus could be transformed into a botanical garden . . . The Camellia Trail, given by Mr. and Mrs. Roy Whitehead of Valdosta, is a great advancement towards the goal. Up to date this trail consists of two hundred plants and ninety-six varieties." (*Campus Canopy, 5/5/45.*)

DR. J. RALPH THAXTON (1901–1982); ACTING PRESIDENT (1948–1949); PRESIDENT (1949–1966). Dr. Thaxton, who received his A.B. and M.A. from the University of Georgia and his Ph.D. from the University of Indiana, served as a professor and dean of the Coordinate College at University of Georgia before assuming the presidency of GSWC. He once said, "The best thing that has happened to VSC . . . was when it became coed." He also presided over the building of seven buildings, and led the school through a peaceful desegregation in 1963. (*VSC Newsletter*, November 1965.)

FIRST OLD ENGLISH CHRISTMAS FESTIVAL AFTER THE WAR. In 1949, the school briefly resurrected the Old English Christmas Festival. They began with a Yule Log Processional, then the carolers, and the Boar's Head. The Lord of Misrule and the fool are familiar figures. Costumed skits, dances, and songs follow and, of course, dancing the minuet. It concludes with a reading of the "Christmas Story" and a Christmas carol. Here is Millie Chitwood in full costume at the 1949 "Olde English Christmas Feaste." (*Campus Canopy*, 12/10/49.)

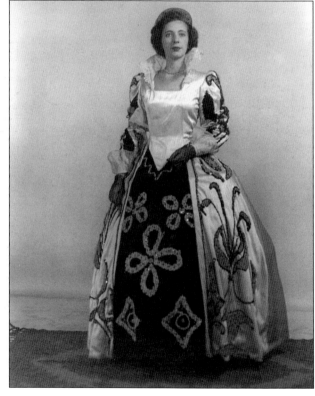

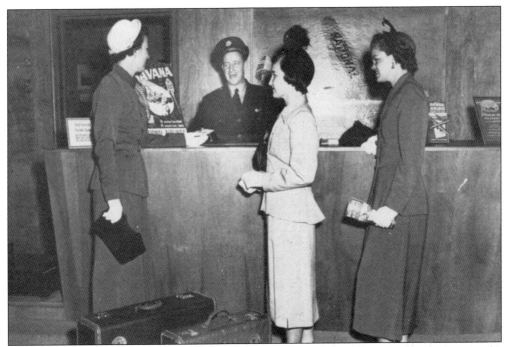

"TICKETS FOR CUBA." The 1950 senior class goes to . . . "Cuba! Cuba! Cuba! That's our battle cry, our motto . . . Perhaps the reason that Cuba means so much to us is the fact that it seems to be what our class stands for, and what we have done to earn it. Our Hallowe'en Carnival, Dances, selling Christmas cards, Constitutions, rosters Amateur show, and etc. have all brought us closer together." (*Pinecone*, 1950, p. 16.)

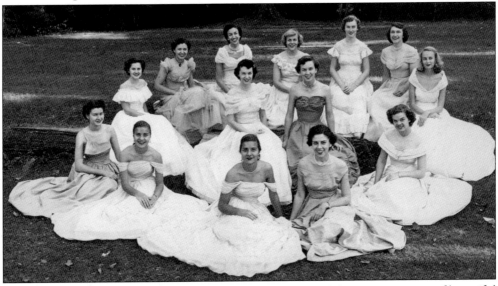

MAY COURT IN 1950. Here, in a brief return to the May Day Celebration, is a court of beautiful young women. Pictured, from left to right are (front row) Anne Bone, Frankie Briggs, Judy Briggs, Francis Paine, and Maxie Warren; (middle row) Barbara Clarke, Ruth Templeton, Jo Anne Story, and Mary Ann McLendon; (back row) Mildred Manley, Sue Belloff, Anna Kennedy, Jackie Norton, and Margaret Traynham. (*Pinecone*, 1950, p. 91.)

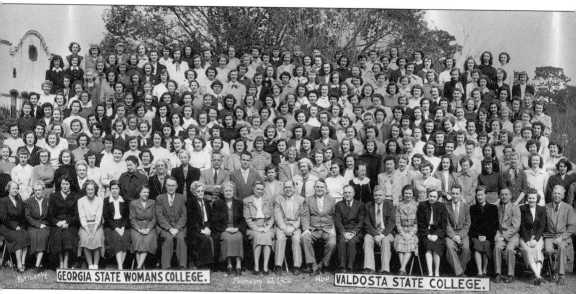

Formerly GEORGIA STATE WOMANS COLLEGE. February 23, 1950 Now VALDOSTA STATE COLLEGE.

VALDOSTA STATE COLLEGE. "The Board of Regents voted Wednesday morning to make GSWC co-educational . . . [It] will become Valdosta State College and will offer co-educational degrees on the bachelor's level . . . Mrs. John Jenkins, Dean of Women, announced . . . That drastic changes will not occur on campus. The Student Government Association will remain the same and the rules and regulations will not be changed . . . The new students would be only day students." (*Campus Canopy,* 1/21/50.)

Five

WHEN THE BOYS CAME: 1950–1966

When GSWC became Valdosta State College, the tenor of the college changed almost beyond recognition. The curriculum reflected the interests of the new students: science and business were popular. Some construction in the1950s and the addition of North Campus when Emory Junior College closed in 1953 gave the school much-needed room. Intercollegiate athletics came with the VSC Rebels: men's basketball and baseball teams. Christmas Fest ended and Homecoming replaced May Day as a "spring event." Fraternities, first, and then sororities, appeared on campus. Pageants and contests, such as Miss VSC, Miss TKE calendar girl, and Homecoming Queen, became important events on campus. In 1963, the college celebrated its 50th anniversary.

But in the fall of 1963, change came to the campus again as Valdosta State went through a peaceful desegregation with the admittance of two African-American students, Drewnell Thomas and Robert Pierce. Both students stayed for the full four years and went on to excel in graduate work and careers. However, the first years of integration, from 1963 to 1967, were lonely and hard. During the mid-1960s, a building boom began on the campus; however, before the construction was completed, ill health prompted Dr. Thaxton's retirement, and Dr. S. Walter Martin, past president of Emory University and vice chancellor of the university system, became the new president.

"LAMENT FOR THE ONCE-LONE SQUAWS" BY BETTY KING. The following lines are taken from the poem by Ms. King: "Boys in the library, boys in the pool, Boys in the classroom, boys in the hall . . . Nice boys, cute boys, quiet boys, Ugly boys, silly boys, smart boys . . . Boys to date and boys to dance with . . . Boys to make a football team . . . Thus will come the boys, The terrible, wonderful boys, Come the boys to VSC." (*Campus Canopy*, 2/18/50.)

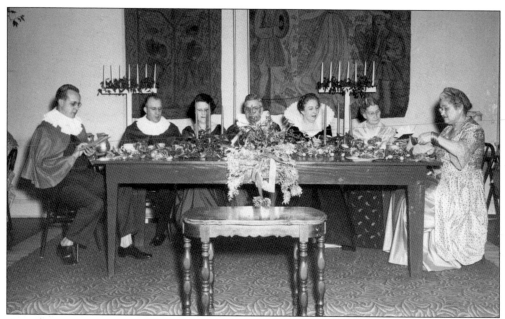

FIRST CHRISTMAS FEAST OF VSC, DECEMBER 1950. Here is the "High Table" from the 1950 VSC Christmas Feast. At the table, from left to right, are Mr. Clifton H. White, professor of fine arts; Dr. Joseph Durrenberger, dean; Mrs. Durrenberger; Dr. Ralph Thaxton, president of VSC; Mrs. Thaxton; Mrs. J.T. Mathis; and Mrs. John Jenkins, dean of women. This was a tradition that soon died out, replaced by more "co-ed" traditions such as the Holly Hop and the Hanging of the Greens. (*Pinecone*, 1951.)

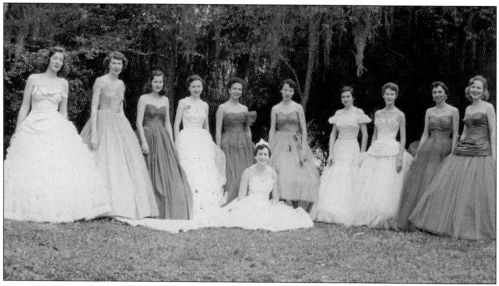

VALDOSTA STATE QUEEN OF MAY AND HER COURT. Shown is the next-to-the-last May Queen and her court. "Wanda Bishop, center, will reign over the May Day [1955]. May Day will be a part of the Alumni Homecoming Weekend and will be held in Drexel Park on the campus . . . Barbara Crew of Cairo, Ga., [is] Maid of Honor. The Court, l-r: Jane Corbett, Jo Ann Hall, Patsy Exum, Janell Connell, Iris Croll, Barbara Crew, Billie Wages, Claire Wiggins, Nancy Lovett, and Carrianne Gothard." (VSU Photograph Collection.)

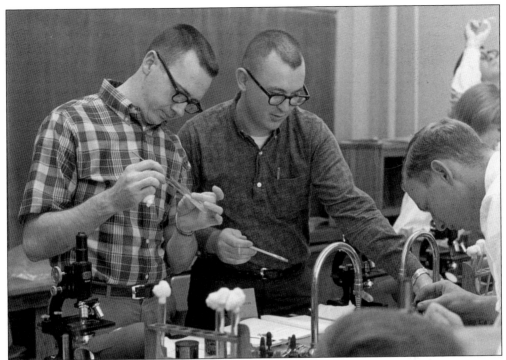

THE SCIENCES AT VSC. "The science division began its most rapid growth when men were admitted. Immediately, pre-dental, pre-medical, and pre-medical technology courses were added to the curriculum with pre-pharmacy courses coming soon afterward. In 1958 . . . [VSC began to offer], in cooperation with Pineview General Hospital, a program of work leading to the BS degree with a major in Biology and Medical Technology." (Hambrick, *VSC: The First Half Century*, p. 73.)

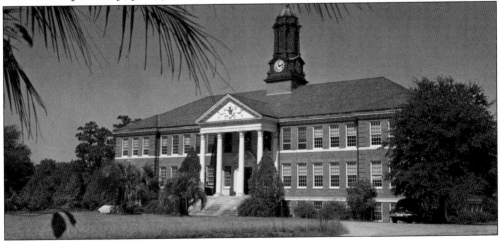

VSC ACQUIRES NORTH CAMPUS. This is the building that became Pound Hall on the campus of Emory Junior College. After the veterans were educated during the later 1940s, and after GSWC became co-ed, Emory Junior College no longer had the enrollment to continue. Its board offered to give the physical plant to VSC when the college closed in 1953. The board of regents accepted since VSC was in great need of space. (*Valdosta Daily Times*, 1953; photo taken by Bookman's Studio for *Valdosta Daily Times*.)

THE GYMNASIUM. "In the fall of 1954, the new $325,000 gymnasium and physical education building was put into operation. Modern equipment and ample proportions provide[d] excellent facilities for instruction in physical education, student recreation, and participation in intercollegiate indoor sports." (*VSC Bulletin*, 1955-56, p. 11.)

THE PALMS DINING HALL. "The dining hall, conveniently located just west of the dormitories on the main campus, is equipped with completely modern furnishings and equipment. The air-cooled building, built to seat 500 students, was completed in the spring of 1955 at a cost for $335,000 for the building and its equipment. The dining hall is under the direct supervision of a trained dietician, and all servants are required to stand periodic physical examinations." (*VSC Bulletin*, 1955–56)

The VSC Rebel Basketball Team, 1955. "Fight and determination make up for lack of height on VSC's 'Rebel' Basketball team. Captain Gene Gray of Columbus, Georgia, makes a jump shot while an unidentified Rebel takes out the opposition. Athletics play an important part in the student life, but no athletic scholarships are awarded." (VSU Photograph Collection.)

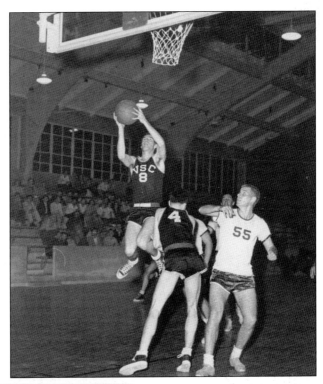

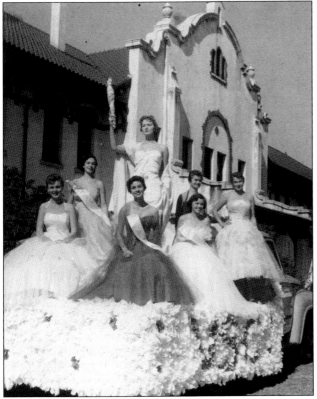

The VSC Float in the Valdosta Veteran's Day Parade. Patricia Arline (standing) represents the Statue of Liberty amid a court of campus beauties labeled as "Patriotic Virtues." The float, sponsored by the student council and created from chicken wire and napkins, won first place in "one of the finest Veterans Day parades Valdosta has every had." (*Valdosta Daily Times*, 11/11/55, p. 1) The following spring (1956) Miss Arline would be crowned queen of the last traditional May Day celebration held on campus.

RAT DAY FUN. "After the testing is over, VSC settles down for a relaxing week of 'Ratting' by the upperclassmen. During Rat Week, freshmen are initiated into college life. On Friday of this week, it is tradition for all freshmen to wear a crocus sack to class." (*Pinecone,* 1966.)

A TYPICAL CAMPUS SCENE. By 1956, the number of men on campus had surpassed the number of women—except for summer enrollment. This would have been a typical student scene from the 1950s. (*Pinecone,* 1956.)

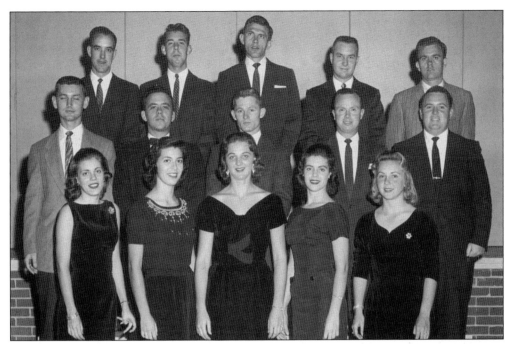

THE FILII FORTUNAE. In the fall of 1951, the "Filii Fortunae," a colony of Pi Kappa Phi, became the first social fraternity organized on campus. It sponsored campus events such as the Miss VSC Beauty Contest. The 1957–58 sponsors, from left to right, are (front row) Mary Ann Morgan, Lucille Helms, Charlene Griffith, Miriam Barnes, and Beverly Monroe; and the 1957–58 brothers (middle row) Joe Smith, Ken Ferrell, Dale King, Charlie Powell, and "Babe" Yeomans; (back row) Bill Kitchens, Jim Hathaway, Jack Rowe, Bill Hayes, and Bill Kent. (*Pinecone,* 1958, p. 90.)

VSC SORORITIES. Alpha Delta Pi was the "first national sorority to be established on the campus of VSC. Sigma Alpha Omega sorority was founded as a colony of Alpha Delta Pi on December 16, 1953." (*Pinecone,* 1959, p. 108.) The 1956 pledge class, shown here from left to right, included (seated) Ann Harris, Anna Lee Smith, Helen Swain, Lucille Helms, Wylena Daugherty, Susie Lindstrom, and Mary Ann Jones; (standing) Hellen Porter, Carol Wiggins, Sandra Shaw, Judy Stringam, Jary Lou Dekle, Betty Kay Springer, Annette Howell, Gloria Dickinson, and Norma Ewing. (*Pinecone,* 1956, p. 83.)

FINS AND FLIPPERS, 1959. "Formed to promote unity and interest among swimmers, the Fins and Flippers has been a popular organization. Formerly for women students only, the club was opened to men students also in 1955. Each spring, the members . . . present a water show [synchronized swimming]." (*Pinecone,* 1959, p. 104.) Shown here, from left to right, are (seated) Joy Collier and Sue Wrigh; (standing) Jackie Moore, Sylvia O'Steen, Mary Shadburn, Dayle Alderman, and Pam Paulk; (on stand) Jeri Martin, Hal Worley, Ann Scala, Laura Leonard (president), and Judy Starling (secretary-treasurer).

MISS VSC 1960. "Between exclamations of thrill and surprise, beautiful Penny Williams was crowned Miss Valdosta State College in the annual contest sponsored by the Pi Kappa Phi Fraternity. Penny, a talented ballet dancer, lists membership in Alpha Delta Pi Sorority, is President of the Dance Club, and serves on the Panhellenic Council." (*Pinecone*, 1960.)

MISS VSC TALENT AT THE ANNUAL TKE TALENT REVIEW, 1960. Marjorie Brooks "did a modern acrobatic dance to Martin Denny's 'Exotica.' The dance symbolized the story of a jungle girl who sacrifices herself to the snake god and in the end becomes a snake herself." (*Campus Canopy*, 2/11/60.)

LITTLE FOXES, **PRESENTED BY THE SOCK & BUSKIN, 1960.** *Little Foxes*, directed by Louise Sawyer opened the 1960–61 VSC theater season. It was "a fabulous success and drew capacity crowds on both nights of production." Here we see "Alan Pendleton [who] portrayed with feeling the sickly Horace Giddens, . . . Sandra Phillips, superb in her portrayal of Alexandra, the chaste daughter of Horace and Regina . . . Christie Yarbrough gave an excellent portrayal of Birdie Hubbard, the alcoholic wife of Oscar." (*Campus Canopy*, 12/14/60.)

THIS LITTLE BUG. "This car found its way into the VSC Dining Hall on Jan 30, [1960]. Looking on is Mrs. Mary Thornton, college dietitian . . . The "bug" car belongs to a co-ed who went home for the weekend . . . It was placed in the lobby of the dining hall sometime after . . . [a] banquet ended last night . . . Who put it in the dining hall . . . None of the VSC students seem to know!" (*Campus Canopy*, 2/10/60, p. 4.)

THE YWCA/YMCA HOMECOMING FLOAT. The 1962 Homecoming Parade featured a combined float for the YWCA, an organization which had been at the school since 1913–14, and the YMCA, organized on campus the first year the school became coed, 1950–1951. Shown here, from left to right, are Thomas Kretlow, Nan Canington, and Lawrence Andrus.

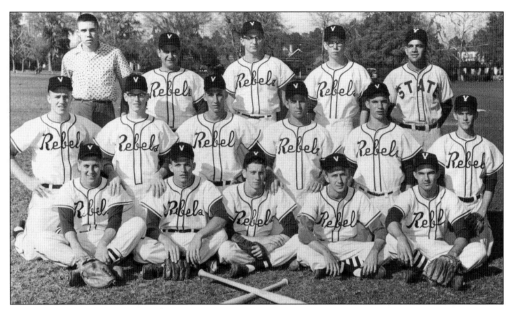

THE VSC BASEBALL TEAM, 1961. Pictured from left to right are (standing) Walter Podein; Joe George; Tommy Thomas, future baseball coach; and Coach Billy Grant, for whom Grant Field is named; (kneeling) Jimmy Hicks; Linda Evans; Steve Chitty; Joe Dixon; Mike Perry, inducted into VSU Athletics Hall of Fame in 1999; and Johnny McIntyre; (sitting) Jerry Greenwald; Herman Hudson; W.A. Carver; Jerry Norman; and Lamar Pearson, VSC/VSU History Professor." (VSU Photograph Collection.)

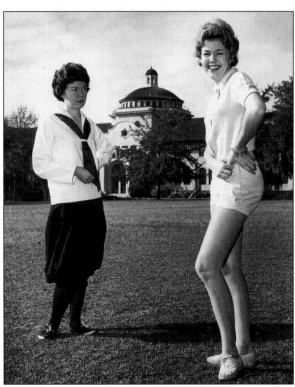

VSC CELEBRATES 50 YEARS. "Ann Powell, in the uniform of the past, and Jeanie Hoyle, in the uniform of today—short shorts and sweater—posed for our cover. Both are Valdosta girls and students at VSC." The *Valdosta Daily Times* did a 14-page feature on the college and its history to celebrate the anniversary on January 8, 1963. (*Valdosta Daily Times*, 1/8/63, *Valdosta Daily Times* photograph.)

SUPPORTING THE REBELS. "The Rebels were preceded to Jacksonville by 32 members of Tau Kappa Epsilon Fraternity who bounced a basketball the entire 125 miles to the Jacksonville University Campus." Pictured here are Gene Goodrum and David Clyatt. (*Pinecone,* 1963, p. 56.)

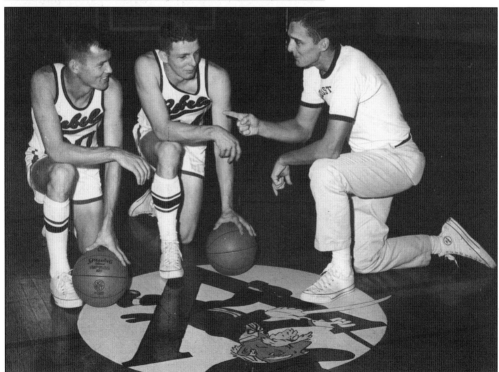

THE 1966 REBELS. Coach Gary Colson and captains Ray McCully and Bobby Ritch are pictured here. Coach Colson and Bobby Ritch were inducted into the VSU Athletics Hall of Fame in 1998. (*Valdosta Daily Times* Index, 1998.)

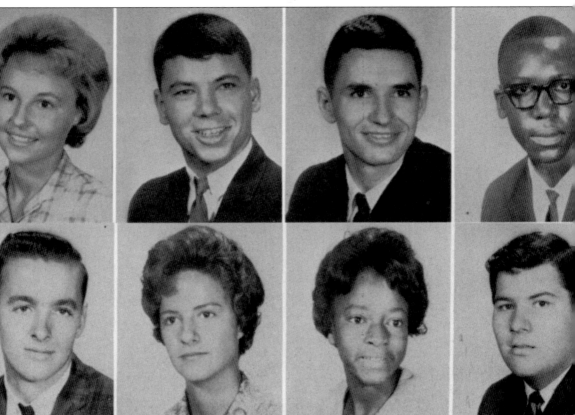

DESEGREGATION AT VSU. Shown are pictures from the 1964 annual. From left to right are (top row) Ameila Paulk, Brian Peters, King Phelps, and Robert Pierce; (bottom row) Brinson Taylor, Diane Thielemann, Drewnell Thomas, and Ronald Thomas. "This year for the first time, the college had Negro students in its student body . . . These two, a local Negro boy and a local Negro girl were the . . . two students . . . eligible for admission . . . [I, President Thaxton] discussed the possibility of integration with various civic groups and I believe that we had the field rather well prepared for integration when the opening of the college came. An injunction was taken out against me, but very little effort was made to serve the . . . paper. The students had been registered before they located me. We were threatened with some disorder by a group . . . and the group did show up on the campus . . . however, the presence of a considerable number of some . . . Patrolmen and some local Police Officers discouraged this group . . . and they left the campus and there was no disorder of any kind." (*Annual Report of VSC*, 1963–64, p. 9–10.)

INTEGRATION, YEAR TWO. Shown is the Collegiate Christian Association from the 1965 *Pinecone*. During 1964–1965, the school had the same two African-American students that it had the previous year. Dr. Thaxton's comment from 1963 applied: "Students accepted the two Negro students with silence. They were two lonely young people throughout the entire year." (*Annual Report for VSC*, 1963–64.) Both students back up Thaxton's impression: Thomas referred to the students' attitude as "cold and hypocritical" and Pierce agreed. (*Campus Canopy*, 4/5/67, p. 4.)

THE GLEE CLUB, 1966. Miss Thomas was most active in extracurricular activities. Here she is shown in the 1966 Glee club with Aurelia Register, the third Negro student who entered the school in 1965–66. Perhaps because of her activities, Miss Thomas had encounters that Robert Pierce did not: "Unlike Pierce [she] had encountered open animosity in students, referring to ugly incidences of name calling from other students." (*Campus Canopy*, 5/4/67, p. 4)

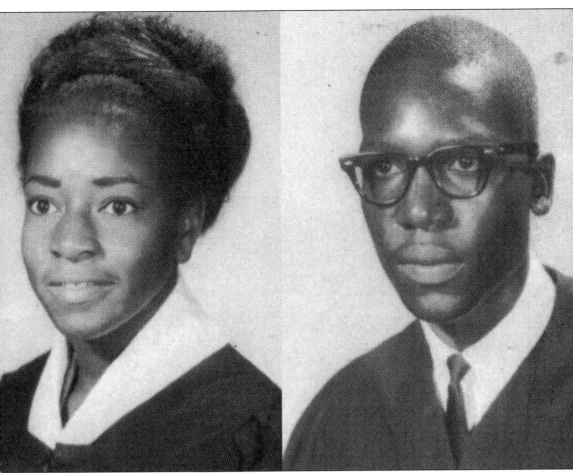

Seniors Robert Pierce and Drewnell Thomas, 1967. At the end of their four year journey, Robert Pierce, "who had turned down a scholarship to Morehouse College . . . to enter VSC because he felt it was something he had to do," summed up his experience: "The atmosphere at VSC was quite different from what I had known in high schoolI was used to having a lot of friends and participating widely in student affairs. However . . . I had anticipated this change and felt that at least I would have more time to concentrate on my academic studies, which would help make up for the lack of activities." Both saw some change in student attitudes over four years, and both commended their professors for the extra help they had given. Thomas and Pierce went on to success with graduate degrees and work in social work and health. (*Campus Canopy*, 5/5/67, p. 4.)

SOCIAL SCIENCES, 1964. "Mr. Saunders Garwood, [assistant prof., history]; Dr. William Gabard, [department head, history]; Dr. Franklin Laurens [associate prof., history]; and Dr. J.A. Durrenberger [department head, sociology] take a rare break from the routine." (*Pinecone*, 1964.)

MARTIN ASSUMES PRESIDENCY IN 1966 AFTER THAXTON'S RETIREMENT. "Dr. J. Ralph Thaxton (left) VSC president, poses with Dr. S. Walter Martin (right) VSC President-Designate in front of VSC's $1 million science-administration building. The building is scheduled to be completed sometime in 1966." (*VSC Newsletter*, v. 2, n. 4, November 1965.)

Six

THE BIG BOOM: 1966–1978

The tenure of Dr. S. Walter Martin coincided with the biggest building boom in the college's history. Construction that had begun under Dr. Thaxton was completed under Dr. Martin, and as part of Martin's inauguration, Gov. Carl Sanders dedicated five buildings. Dr. Martin, past president of Emory University and past vice chancellor of the University System of Georgia, presided over a time of physical growth and social change for the college. The library, the Fine Arts Center, the Education Center, and three more dormitories added to the total construction, as well as numerous remodeling projects. Programs begun included Nursing and the Air Force ROTC.

Socially, Miss Annie Powe Hopper would have no longer recognized the college. While Greek activities and pageants seemed to get ever more popular, signs of social change common during the 1960s and 70s across the country appeared at VSC. Students actively protested (and supported) the Vietnam War. The school's desegregation began to bear fruit with black scholars, athletes, homecoming queens, and artists. In an inclusive gesture, the name of the college sports teams was changed from the Rebels to the VSC Blazers. Drug use appeared on campus and "streaking" caused a brief sensation. Of more lasting importance was the inauguration of women's intercollegiate sports—the Lady Blazers—in 1973, something the alumni had requested in the 1920s!

DR. SIDNEY WALTER MARTIN, PRESIDENT OF VALDOSTA STATE COLLEGE, 1966–1978. Dr. Martin, received his A.B. from Furman University, his M.A. from the University of Georgia, and his Ph.D. from the University of North Carolina. He was a professor and a dean at UGA for 22 years, president of Emory University for 5 years, and vice chancellor of the University System of Georgia, before becoming president of VSC in 1966. Dr. Martin, an active leader in the United Methodist Church, presided over a building boom at VSC and greatly expanded VSC's programs, especially the School of Nursing. (Martin Papers, VSU Archives.)

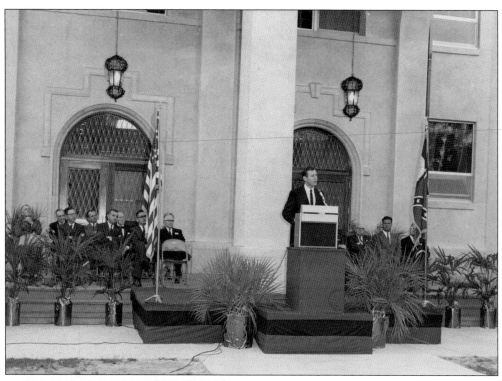

GOVERNOR SANDERS DEDICATING NEVINS HALL, 1966. Gov. Carl Sanders gave the dedicatory address on November 14, 1966, for all of the buildings constructed at VSC during his tenure as governor of Georgia. The buildings include the College Union and Nevins, Hopper, Brown, and Lowndes Halls. Nevins Hall was "erected at a cost of $1,063,452 . . . [and was] named for the late Dr. Beatrice Nevins, head of the VSC Biology Department for 26 years." (Dedicatory Program, VSC, 11/14/66.)

THE PLANETARIUM. "The Department of Physics, Astronomy, and Geology operates a Spitz A3P planetarium housed in a 24-foot dome, with the capacity to seat 60 people. The planetarium presents a realistic display of the night sky as seen by the unaided eye . . . [It] is used for college classes, for public programs, and for shows presented to civic groups and to visiting school groups." The planetarium opened in April 1967. (*Pamphlet*, Physics, Astronomy and Geology.)

College Union. "Taking the place of the old Student Center is the sparkling new $409,575 College Union offering a snack bar, meeting rooms, post office, and bookstore." (*Pinecone,* 1967) It was built around two sides of the swimming pool.

Brown Hall and Lowndes Hall. This picture, taken from the tennis courts where the Odum Library is now, shows the newly built Brown Hall. At the far right is Lowndes Hall, which is under construction. Brown Hall was named for Joseph M. Brown, governor of Georgia when the school opened in 1913, and Lowndes was named for William Jones Lowndes, "nationally recognized educator and statesman." Both buildings hold 200 students each. (Dedicatory Program, 11/14/66.)

MICROFILM. Ray Register reads microfilm in the library (Powell Hall at that time). (*Pinecone*, 1967.)

THE PANNKOKE COLLECTION. Karen Luke, president of SGA, and Richard Vann examine the carved figures donated by O.H. Pannkoke. Dr. Pannkoke was a "nationally known creative pioneer in the field of Lutheran unity, higher education, stewardship, public relations, and theology." The collection includes mostly carvings of pioneer scenes by George Zier and is on permanent display in the Odum Library. (*College Relations News Bureau*, 2/22/68.)

CAROL AND SAM. "Carol E. McKinley, Pi Kappa Phi's 1968 Sweetheart, and Sam the dog, are pictured here." (*Pinecone,* 1968). Starting in 1966, Sam was the "unofficial mascot of the school." He was featured nationally in 1966 in many newspapers and appeared regularly in the *Atlanta Constitution* and the *Valdosta Daily Times.* He lived officially with the Snows on Alden Avenue, but spent so much of his time at the school that he became known as "The King of VSC." (*Campus Canopy,* 10/18/68.)

FOUR OF **VSC's** BEST DRESSED, **1967.** Here, from left to right, are Caroline Bozeman, Anne Whiddon, Gwen Hiers, and Peggy Herring (VSU Photograph collection). The Annual Best Dressed list was "judged on a basic understanding of figure type, a well organized clothes budget, good grooming, and correct use of Make-up." The winner from the 10 best dressed (Ju Ju Hutchinson, not pictured here) had her picture sent to *Glamour* magazine's national contest. (*Pinecone,* 1967.)

GEORGIA HALL, READY FOR OCCUPANCY IN 1969. "The three story dormitory building contains 100 student bedrooms housing two students per room." The first floor has a "house director's apartment . . . [with] student apartment[s] on both the second and third floor. Also on the first floor are two lobbies, a student kitchen, a trunk storage room, a study, an office, a laundry area, vending or snack area, and the main and television lounges." (Papers, Building Collection, VSU Archives.)

LANGDALE HALL, UNDER CONSTRUCTION, 1968–1969. Langdale Hall, the tallest building on campus, "is located near the center of campus, between the college Infirmary and Reade Hall. It will house 500 women." (Papers, Buildings Collection, VSU Archives.)

THE FINE ARTS BUILDING, DEDICATED APRIL 7, 1970. The Fine Arts Building "houses the Departments of Art, Music, and Speech and Drama. The 83,000 square-foot structure was constructed at a cost of $2,000,000. In addition to carefully planned teaching areas and faculty offices, the building contains an art gallery, production lab theatre, radio and television studio, a Little Theatre, seating 244, and The Whitehead Auditorium, seating more than 800." (*Dedication of Fine Arts Building Pamphlet.*)

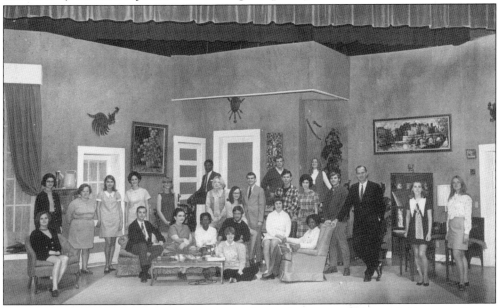

SOCK AND BUSKIN, 1970. Pictured here, from left to right, are (seated) Kendra Hargett, Danny Peterman, Carol Clay, Mary Robertson, Vicki Vickers, Steve Seyfried, Fraser Russell, Nadeen Green,and Bessie Thompson; (standing) Sharon Bostick, Diane Taylor, Liza Cooper, Sherron Long, Kay Williams, Clifton Young, Sharon Costello, Riley Wade, John McRae, Dwane Pitts, Beth Jones, Marcia Owens, Jim Hicks, Mr. Hitchcock, Lynn Hodge, and Elinor Davis. (*Pinecone,* 1970.)

VSC AND THE VIETNAM MORATORIUM DAY. Activities on campus included a "memorial graveyard honoring the Americans killed in Vietnam. . . . An open [panel] discussion, held in Whitehead Auditorium drew interest and participation . . . And a petition circulated asking for an end to the war." (*Campus Canopy*, 10/20/69, p. 1.)

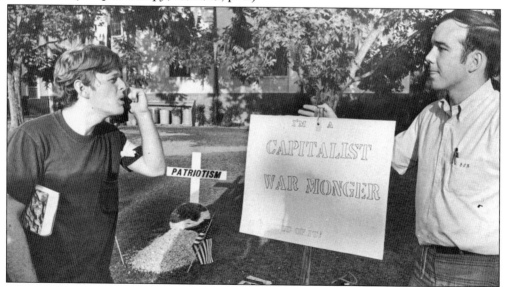

COUNTER-PROTEST. Above, "one group of students on campus set up [a] grave marked patriotism near the memorial graveyard in expression of their belief that dissention of the war in Vietnam is Un-American." Here is a confrontation that resulted. (*Campus Canopy*, 10/20/69, p. 1)

SEASONED TO PERFECTION. This stylized photograph graced the front of the 1970 *Pinecone*. VSC had drug use in the early 1970s, as did most college campuses. One response to the problem was the formation of a board of regents mandated "Drug Committee" composed of students and faculty. The committee debated their role with regard to the law: "The Student Committee on Drugs doesn't stop people from using drugs . . . its most important function is to help the people who are having problems with dope." (*Spectator,* 10/27/70, p. 10.)

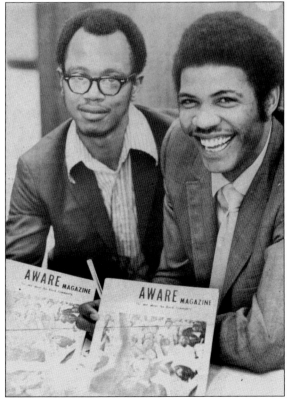

BLACK STUDENTS LEAGUE. "We, the students of VSC, feeling a need to promote the ideals of human dignity, respect, and pride, to encourage cultural and historical awareness, to aid and encourage the underprivileged and the oppressed, to attack shame and hypocrisy whenever and wherever it appears . . . do hereby establish the Black Students League of Valdosta State College." (*Pinecone,* 1970.)

JOYCE JOYCE. "Joyce Ann Joyce, a graduating senior at VSC majoring in English, has received a scholarship for graduate study at the University of Georgia." Joyce finished an M.A. at UGA in English in 1972 and then taught at VSC. She completed a Ph.D. in 1979 at UGA. She is the author of four books and is currently head of the African-American studies department at Temple University in Philadelphia.

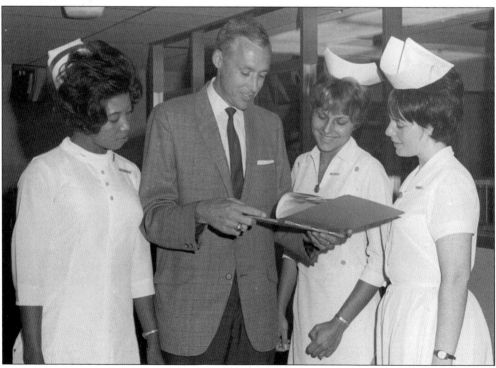

THE VALDOSTA STATE COLLEGE NURSING PROGRAM. In 1967, the board of regents granted VSC authority to offer a B.S. in Nursing. "Clinical experience will be provided in local health facilities, including Pineview General Hospital, Lowndes County Health Department, convalescent centers and physicians' offices and other related units in the South Georgia area." (Nursing Program brochure, 1968) Pictured above are Dr. William Gee and nurses at the Pineview General Hospital.

CLIFTON YOUNG SINGS "DOWN IN THE VALLEY." The first "opera staged at VSC 'Sunday Excursion,' was short but delightful. However, it was [Clifton Young's performance of] 'Down in the Valley' that was the highlight of the evening." (*Pinecone*, 1970, p. 26; photograph by Ed Green.)

THE RADIO STATION. WVVS-FM "the 'Voice of Valdosta State' operates from the second floor of the Student Union and broadcasts over a 30-mile radius at 89.9 MHz on the FM dial." Bill Tullis, from Valdosta, is program director for WVVS. (*Spectator*, 9/24/71; photograph, 1973.)

THE LIBRARY, DEDICATED 1972. "The building, . . . located between the College Union and Brown Hall, . . . [is] approximately 100,000 square feet and three stories high." (*Alumni Newsletter*, July 1969.) It "has a total seating capacity of 1,119 readers. The new building can accommodate up to 450,000 volumes." (*Alumni Newsletter*, April 1972.)

THE EDUCATION CENTER. "The Regional Education Center at Valdosta State College is one of the most modern such facilities in the country . . . The 71,000 square foot structure cost $2,000,000. Housed in the building are the School of Education (departments of education, psychology and physical education), Division of Public Services, the Learning Skills Laboratory and the College Counseling Service." (*Dedication of the Education Center Pamphlet*, 1973.)

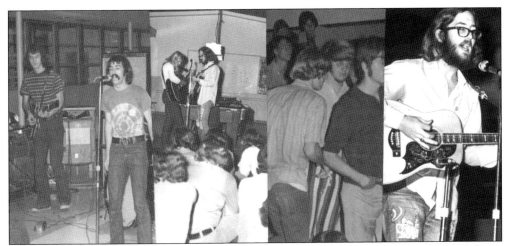

JAM SESSIONS. "Complete with everything from guitars to a Jew's harp, this year's jam sessions provided Thursday night entertainment at its best. The jams, sponsored by the College Union Board, rang well into the night as local musicians proved their talents to enthusiastic crowds. Names such as John Walters, Marty Bone and Russ Moore claimed the spotlight while their music was amplified across the VSC campus." (*Pinecone,* 1972.)

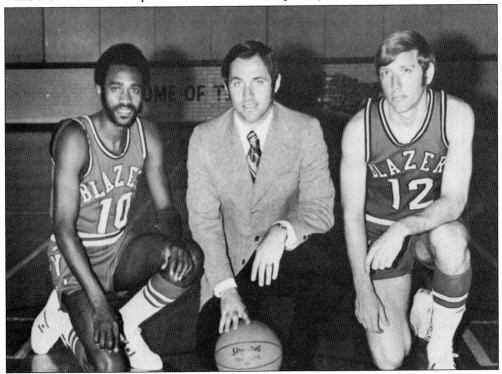

THE BLAZERS, 1973. Between 1972 and 1973, VSC changed its sports teams' names from Rebels to Blazers. "Willie Oxford (left) made NAIA All-American for the third straight season while averaging 19.1 points per game . . . Tim Dominey (right), the younger brother of VSC coach James Dominey (center) (college coach of the year in Georgia) wound up the year with an 18.0 per game average and a contract with the Atlanta Hawks professional basketball team." (*Pinecone,* 1973, p. 108–109.)

SKIP MCDONALD, FIRST VSC AFRICAN-AMERICAN HOMECOMING QUEEN. Here is 17-year-old Skip McDonald from Adel in October of 1973, performing in the Black Student League's "A Tribute to Billie Holiday." "Skip left the audience open-mouthed and often filled their eyes with tears." (*Spectator,* 10/10/73.) Skip said, "[that night] was one of the most exciting nights of my life . . . I chose to pay a tribute to Billie Holiday . . . after seeing the movie *Lady Sings the Blues.*" (*Pinecone,* 1974,p. 14.)

SMILING THROUGH HER TEARS. "Caught between laughter and tears of joy, Skip McDonald of Adel is crowned 1974 Homecoming Queen at Valdosta State College by her predecessor, Sue Ellen Clyatt of Macon. Standing ovations are not new for the 17-year-old daughter of Mr. and Mrs. T.R. McDonald. A sophomore nursing major, Skip brings down the house every time she sings." (*VSC News Bureau,* 2/21/74.)

THE RESPECTFUL PROSTITUTE. Sartre's play *The Respectful Prostitute* offers "South Georgia [the chance] to take a look at their race relations through the eyes of Jean-Paul Sartre." Here, "Production Assistant Joe Ippoliot (right) makes a point as he coaches Monica Miller (left). Prof. Lee Bradley, arms akimbo, stands by with Joe Brown during rehearsal of Sartre['s] play at VSC." (*Spectator*, 4/4/73, p. 7.)

MAKING HISTORY AT VALDOSTA STATE COLLEGE. "Valdosta State College President S. Walter Martin stands by as Lt. Col. Raymond F. Hamel administers the oath commissioning Richard Moore, John Wagner, and Richard K. Winston Jr. (from left) second lieutenants in the U.S. Air Force Reserve." (*VSC News Bureau*, 6/7/73.)

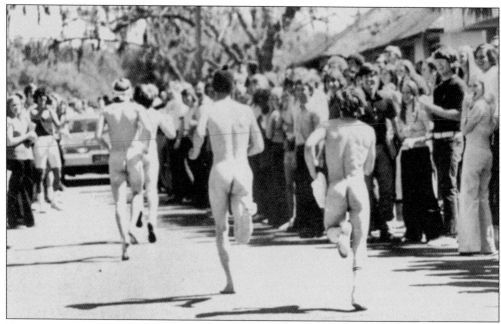

STREAKING. "A few VSC students like to show their true natures: or perhaps just their better halves . . . Without a doubt the recent rash of streaking has generated more enthusiasm on the VSC campus than has any other activity in the past several years." (*Spectator,* 3/13/74.)

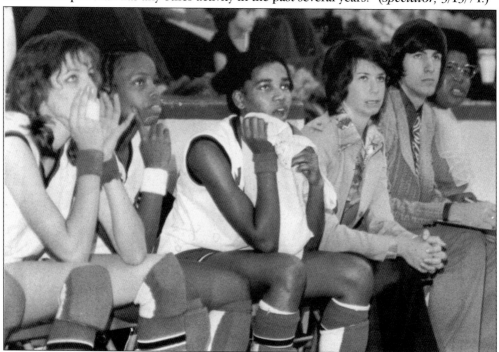

THE LADY BLAZERS VS. SAVANNAH STATE, 1976. "Action is always fast and furious, and sometimes tense, as expressed on the faces of Lady Blazers (l-r) Linda Carratt, Gwen Durham, Bessie Bloom, Coach Lyndal Worth [first Women's Basketball Coach at VSC], managers Bob Connell and Glenda Battle." (*Spectator,* 1/15/76, p. 9.)

Seven

GROWING UP: 1978–1993

In the spring of 1978, with Dr. Martin's retirement looming in the summer and the college in the midst of a search for a new president, Converse Hall, VSC's most historic building, burned. The new president, Hugh C. Bailey, an Alabama historian and administrator, arrived in the summer. It may be a coincidence of background and timing, but Dr. Bailey would go on to preside over a renovation of some of the oldest buildings on campus.

During this era, Blazer sports excelled with the new physical education building and a national championship baseball team. Football began at VSC in 1982, and in 1983 the Blazer football team played in the Gulf South Division II Conference. The Blazin' Brigade, the VSC marching band, began in 1983. The VSC student population almost doubled during this period, with student activities from the silly to the serious taking off.

Along with increased student activities, larger student numbers brought more programs and expanded services. Through the 1980s and early 1990s the school added satellite locations and graduate programs. The non-traditional student became common on campus, and the college used a variety of funding sources to expand services and purchase or renovate buildings.

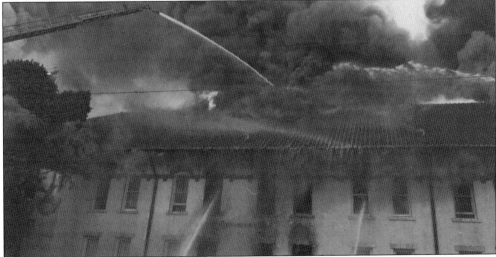

HISTORY GOES UP IN SMOKE. "Valdosta State College lost a part of its history . . . when fire swept through Converse Hall on Friday [April 14, 1978] destroying the landmark and leaving 61 students homeless." (*Spectator*, 4/20/78, p. 1.) "This place has represented college for hundreds and hundreds of people. It's like a whole part of our history is burning down,' said VSC Vice President Ray Cleere." (*VSC Bulletin*, May 1978.)

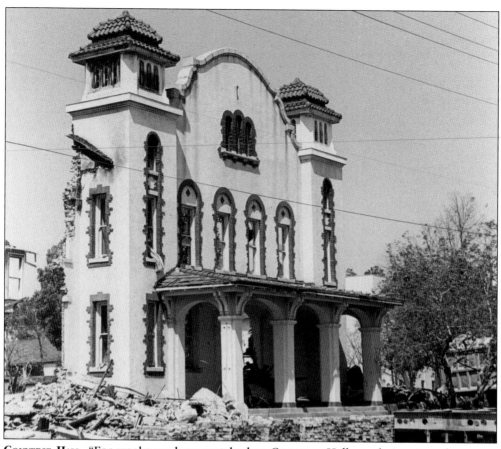

CONVERSE HALL. "For weeks we have watched as Converse Hall was being torn down . . . Almost a year since Converse Hall burned, the old familiar structure is now being torn down . . . Some are a little sad to see Converse fall to the ground, others are happily awaiting the 'new' Converse that will take its place." (*Spectator,* 4/5/79, p. 1.)

VSC's NEW PRESIDENT (1978–2001). Dr. Hugh Coleman Bailey, who received his A.B. degree from Samford University (then Howard College) and an M.A. and Ph.D. from the University of Alabama, all in history , came to VSC in 1978 from Francis Marion College, where he served as vice-president and academic dean. Past administrative achievements include "restructuring the curriculum, viable honors programs, involving the students, faculty and administration in an open dialog." Of VSC, Bailey said, "We have to be very respectful of students . . . treat them as you want to be treated." (*Spectator*, 9/28/78, p. 1.)

PRESIDENT BAILEY. "The inauguration of Dr. Hugh Coleman Bailey as president of Valdosta State College was a glorious academic festival. More than 100 institutions . . . were represented by richly robed delegates in full, colorful academic regalia." An excerpt from his acceptance address grew to be a common description of the college: "The potential exists . . . for Valdosta State to become a veritable jewel in the Georgia University System." Shown in the picture above is President Bailey and Mrs. Bailey with their daughter Debbie, age 10. (*Valdosta State Bulletin*, May 1979, p. 1.)

COMING UP ROSES AT VSC. "'We didn't promise you a rose garden, but here's one anyway, Happy Inauguration Week to the Baileys!' That was the message on the card accompanying the gift of 38 rose bushes of many varieties from the deans and directors of Valdosta State College to Dr. and Mrs. Hugh C. Bailey Monday afternoon. The surprise gift marks Bailey's investiture as sixth president of VSC, set for April 30, 1979. (Bailey Papers, VSU Archives.)

THE OLD AND THE NEW: CONVERSE HALL. "New Converse Hall opened this fall quarter, with 91 attractively furnished efficiency and one-bedroom apartments for students. Built on the site of the original Converse Hall, the architecture combined the familiar old arches at the main entrance with the new three floor apartment wings." (*VSC Bulletin*, November 1981.) Some of the same brick and cast stone of the original building was used in "New Converse." (*Spectator*, 3/6/81.)

BASEBALL BLAZERS, NO. 1 IN NATION. "They were called the mystery team. The cardiac kids. There were no superstars. The hitting and pitching were only a cut above average. All they did was win . . . and win . . . and win . . . until their final victory was the biggest of all . . . Coach Tommy Thomas' Blazers . . . are the 1979 National Champion of the NCAA Division II baseball." (*VSC Bulletin*, August 1979; photograph courtesy of Coach Thomas.)

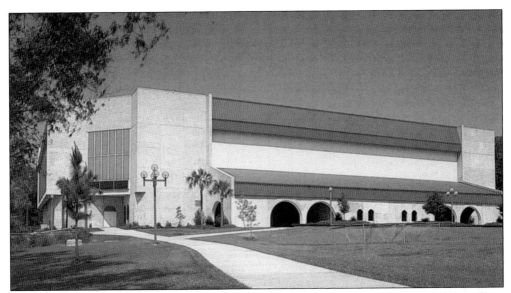

THE VALDOSTA STATE P.E. COMPLEX, 1982. The new Physical Education Complex "brings to fruition years of dreaming, planning and hard work . . . The splendid new facilities will provide opportunities for greater service to all South Georgia, and enable Valdosta State to do a better job in fulfilling its service mission." (Hugh C. Bailey, president, PE Complex Dedication Program, 1982.)

THE $6 MILLION FACILITY. "The facility contains 105,591 square feet of floor space with a . . . seating capacity of 6,000 for basketball games. Also, it provides locker rooms, classrooms, offices, gymnastics/wrestling areas, a mezzanine with four-lane running track, volleyball and half-court basketball for the College's physical education program." (Physical Education Complex Dedication Program, 1982.)

111

VSC FOOTBALL TEAM. "Football at Valdosta State College? Yes! Football at the 75-year old institution is to become a reality with the fall of 1982. In a June 3 referendum, VSC students gave overwhelming approval to raise student activity fees to finance a football team. When the final votes were counted, 80 percent of those voting said 'yes' to fielding a team." Shown are scenes from the 1982 VSC football season. (*VSC Bulletin,* August 1981.)

JIM GOODMAN, FIRST BLAZER FOOTBALL COACH. "Jim Goodman in 1981 accepted the tremendous challenge of starting an intercollegiate football program at Valdosta State. Less than 10 months after he came on the job, he sent a group of inexperienced players onto the field . . . The final ledger read 5-5-1 . . . indeed a much better record than anybody had predicted." (Program, VSC vs. Delta State University, 10/8/83, p. 8.)

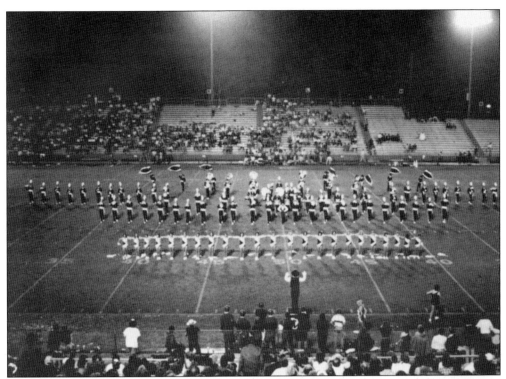

THE BLAZIN' BRIGADE BEGINS. "For the first time in the history of Valdosta State College, there is to be a Marching Band beginning in the fall quarter. According to Dr. Bailey, 'A marching band will fill a vacuum in our music department and increase comprehensiveness for our music students who desire to participate in band music' . . . The Blazing Brigade began in the fall of 1983." (*VSC Bulletin,* August 1983.)

THE VSC AMBASSADORS. "Approximately 20 Valdosta State students will be selected as 'VSC Ambassadors,' a prestigious, exciting organization to . . . represent . . . the college at a number of activities both on and off campus . . . They will act as hosts and hostesses for numerous campus special events, speak at off campus activities and assist with student recruitment and alumni relations." Fluker Stewart, bottom right, is the campus advisor. (*Spectator,* 9/28/83, p. 2.)

MR. PYTHAGORAS AND DR. RON BARNETTE, 1980–81. "Mr. Pythagoras has arrived on the scene here at VSC and will be opening up his practice for the benefit of students, faculty, or any interested party." Mr. Pythagoras, a numerologist composed of John Robbins (the suit) and Alan Bernstein (the words), took an active role at VSC in 1980–81. He wrote a weekly column, ran (unsuccessfully) for president of the SGA, and appeared often as a surprise-visiting lecturer in philosophy and political science classes. (*Spectator*, 10/3/80, p. 7.)

VALDOSTA STATE HISTORY ARCHIVES. "A long-time dream at VSC has become a reality with the establishment of the Archives for Contemporary South Georgia History. Dr. Dale H. Peeples, history professor and chairman of the Special Collections and Records Management committee, is in charge of the archives, housed in the lower level of the VSC library." (*Spectator*, 9/28/83.) Eighteen years later, the archives is still in the library and Deborah Davis, archives librarian, administers it.

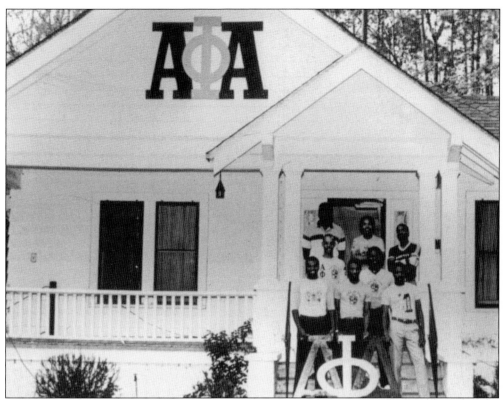

ALPHA PHI ALPHA. Alpha Phi Alpha was one of five or six African-American Greek organizations that came to VSC in the mid–1970s. Here are the members in front of their house, acquired in January of 1981. In 1983–84, "The Mu Omicron chapter of Alpha Phi Alpha at Valdosta State College . . . [had] eleven members and . . . [had] maintained the highest GPA of all the fraternities on campus for winter and spring quarters 1984." (*Milestones,* 1984, p. 84.)

PAM JOHNSON, WOMEN'S BASKETBALL. The 1983–84 Lady Blazers had a stellar season. They won 30 of 33 games and reached the Final Four in NCAA Division II Women's Basketball. Two stars of the team were power forward Janice Washington, and 6'5" center Pam Johnson (shown), who led the team "in scoring and rebounding." (The 1984–85 Lady Blazers Program.)

115

VALDOSTA STATE'S BEAUTY PAGEANT WINNERS. The VSC Coeds in the 1986 Miss Georgia Pageant, from left to right, are Miss Golden Isles, Glynis Attaway; Miss Albany, Deana Luke; Miss Thomasville, Krista Kinert; Miss Southeast Georgia, Marlesa Ball; Miss Valdosta, Kelly Edwards; Miss North Central Georgia, Laura Lee; and Miss VSC, Mary Powers. (Photo by Allen Horne, *Columbus Ledger-Enquirer*.) "One, Marlesa Ball, not only won the title [Miss Georgia] but ranked in the top ten in the Miss America Pageant." (*Spectator*, 9/24/86, p. 7.)

VSC's Mascot. "At Cleveland Field Saturday [November 14, 1987] where the Blazers hosted Delta State, fans witnessed the birth of a seven-foot-tall dragon . . . Blaze is computerized to wiggle his ears, light up his nose, blow smoke, and blink his eyes." Mr. and Mrs. Tommy Pritchett and Mr. and Mrs. Jimmy Allen of Tifton, Georgia, gave him. (*Spectator*, 11/18/87, p. 3.)

116

BLAZE AND MRS. JOAN BAILEY WITH BOB HOPE. "Internationally known entertainer Bob Hope performed Friday evening at the Physical Education Complex on the campus of Valdosta State College. The show was the highlight of VSC's Homecoming '88.' " (*Valdosta Post*, October 22, 1988.)

JESSIE TUGGLE AT VSC. Tuggle's VSC football career lasted from 1983 to 1986. His accolades while at VSC include, "VSC's Best Defensive Lineman in 1985 . . . in 1986 the [Gulf South Conference] voted him its Player of the year . . . He joined the Atlanta Falcons in 1987 . . . and led the NFL in tackles in 1990." As an alumni and professional athlete, he has supported his alma mater. The Jessie Tuggle Fitness Center is named in his honor. (*Spectator*, 10/10/91, p. 9.)

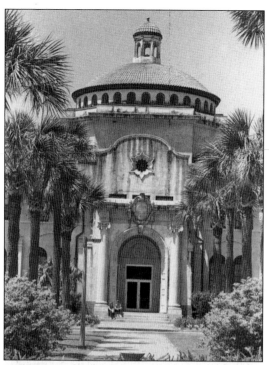

WEST HALL. "The oldest building standing on the Valdosta State College campus will undergo a major restoration program, beginning in December [1986] . . . 'We are so pleased West Hall can be restored and . . . an addition added which will fulfill the original design conceived by the architect over 70 years ago.' " (*VSC Bulletin*, November 1986.)

DOWN TO THE GROUND FLOOR. "Construction workers have literally gotten down to the ground in the process of renovating West Hall at Valdosta State College . . . The interior of West Hall, the oldest building still standing on the college's campus, is being gutted and rebuilt and the exterior is being restored to its original Spanish Mission architecture." (*VSC Bulletin,* August 1987.)

118

THE ROTUNDA DOME OF WEST HALL. "The glory of the facility, however, is the great three-story rotunda. The second and third floor areas directly under the dome have been removed and a 70-foot rotunda created. Its center is a beautiful bronze medallion, containing the great seal of the College, which features the exterior dome itself. The Medallion is implanted in a green marble floor which greatly enhances its beauty." (Dr. Bailey, *VSC Bulletin*, May 1989.)

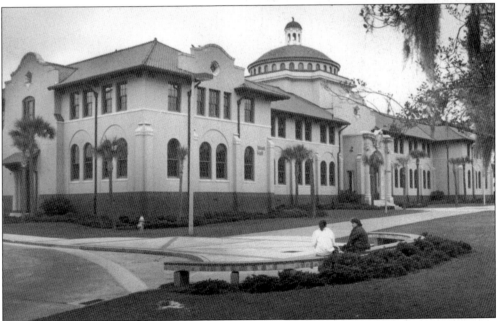

WEST HALL; A SHOWPLACE FOR US ALL. "After years of struggling for funding and over two years of construction time. . . The new West Hall has been restored and built in exact conformity with the original design of the building produced in 1910. . . . The area many of you knew as the Annex . . . has been rebuilt as it was originally designed to be. In addition, the projected two-story section at the rear, which was never constructed, has been added." (Dr. Bailey, *VSC Bulletin*, May 1989.)

GOVERNOR'S HONORS PROGRAM. GHP is an "intensive six week residential institute for some of Georgia's best and brightest . . . 'GHP is considered to be one of the very finest experiences in secondary education in the country' . . . The presence of the Governor's Honors Program on the Valdosta State College campus has benefited the college in many ways." (*VSC Alumni Bulletin,* August 1992, p. 3.)

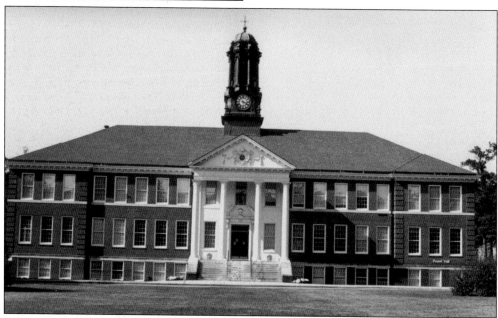

POUND HALL: TOPS IN TECHNOLOGY. Two years of construction and remodeling have "transformed Pound Hall into a top-notch teaching facility . . . 'This renovation was a result of a very creative financing partnership between the university system, the college and private support.' " (*VSC Alumni Bulletin,* August 1992.) In Fall 2000, the College of Business Administration received a $1 million gift to further support faculty and technology. Its new name recognizes that gift: the COBA is now the Harley Langdale Jr. College of Business Administration. (*Valdosta Daily Times,* 11/17/2000, p. 1.)

120

Eight

A REGIONAL ADVENTURE: 1993–2000

On July 1, 1993, after years of work and lobbying, VSC became Valdosta State University (VSU), the second regional university in the University System of Georgia, with a special responsibility for the professional graduate needs of its service area. VSU's service area would reach from the Georgia Coast to the Alabama line and encompass all of South Georgia. VSU is a school increasingly technological, increasingly diverse and international, and, unfortunately, increasingly squeezed for space. The school has found room for growth through renovating many of the homes and buildings surrounding the college. The University Center, now a showplace of Spanish Mission architecture, was created from a 1960s strip mall.

As part of its regional mission, VSU expanded its graduate programs to include doctorate degrees and new masters degrees in fields such as social work and library science. The late 1990s have seen a steep increase in admission standards and a blossoming scholarly production. After years of conversion and renovation, Valdosta State has begun a new on-campus building campaign with the science building, a new library addition, a new student recreation center, and a new special education/speech language pathology building.

CARNIVAL AND FIREWORKS. On the night of June 30, 1993, thousands gathered to welcome the regional university that would be "born" at midnight. Events included unveiling the Valdosta State University arch, "cutting a giant cake in the image of West Hall," and a countdown to midnight by thousands of voices. (*VSU Alumni Bulletin*, Fall 1993, p. 1.)

THE ROAD TO VSU. The following changed VSC to VSU:

• 1988—The general assembly passes resolution encouraging board of regents (BOR) to set up two more universities in state.

• 1989—BOR consultants propose raising Georgia Southern to regional university status in July 1990 and Valdosta State in July 1992. Also, the regents adopt a proposal for VSC and Albany State to get dual status and bring more graduate classes to Albany

• 1990—Georgia Southern becomes a regional university; regents affirm commitment to VSC, but drop Albany State.

• 1992—Regents decree VSC would become a regional university, but must wait a year due to a poor economy; Governor Zell Miller allocates $375,000 from his emergency fund to VSC for regional university planning.

• 1993—A total of $1.2 million for the first year of university status is placed in proposed budget; in March, a committee removes the $1.2 mil from budget, but two days later after midnight lobbying, the money is returned. On July 1, VSC becomes VSU! Whew!

(*Valdosta Daily Times*, 6/27/93.)

GEORGIA POWER BUILDING. "Because of the cooperation of the Valdosta State Foundation, the office of Public Services occupied the major portion of the former Georgia Power building, obtaining much needed space for developing continuing education and other programs." (*President's Annual Report*, FY 1993, p. 2.)

INTERNATIONAL EXCHANGE STUDENTS AT A DINNER CELEBRATION. According to Tracy Harrington, director of international studies at VSU, "if we are to give our students a university education—which after all means universal—then we must equip them with the knowledge, skills and perspectives they need to be informed, competent citizens of the World." (*VSU Alumni Bulletin*, Fall 1994.)

BROOKWOOD PLAZA. "Formerly a strip mall called Brookwood Plaza, the 128,000 square-foot University Center . . . combines classrooms, a 200-seat food court and student lounges in what used to be a Pantry Pride grocery store, the old Sears store, Woolworth's and other smaller stores." Above is Brookwood Plaza before renovation began. (*Valdosta Daily Times,* 10/15/95, p. 1.)

THE VALDOSTA STATE UNIVERSITY CENTER. In 1993, Dr. Bailey received a citation from the Georgia Association of the American Institute of Architects for "the consistency of its Spanish mission-style on a campus of both contemporary and traditional buildings." (*VSU Alumni Bulletin,* Winter 1993.) The University Center expanded that tradition of design excellence: "You'd never believe you could turn a shopping mall into something that looks like it was site built," Dr. Stephen Portch [university system chancellor] said. (*Valdosta Daily Times,* 10/15/95, p. 1.)

JANICE DAUGHARTY, VSU WRITER IN RESIDENCE. "Students of creative writing now have as a resource one of the nation's most critically acclaimed new novelists as Valdosta State University names its first-ever writer-in-residence. Janice Daugharty, author of *Dark of the Moon, Necessary Lies, Going Through the Change,* and *Pawpaw Patch* has been appointed Writer-in-Residence." (*VSU Alumni Bulletin,* Fall 1996, p. 24.)

DR. RON BARNETTE AND PHICYBER. " 'What would happen if a group of university students met and engaged in philosophical dialogue without being in each other's physical presence—knowing each other only through identification based on computer exchanges?' Dr. Ron Barnette began with this question. Two years later, his students debate ethics and the essence of truth on computer keyboards in 11 countries." (*VSU Alumni Bulletin,* Fall 1996.)

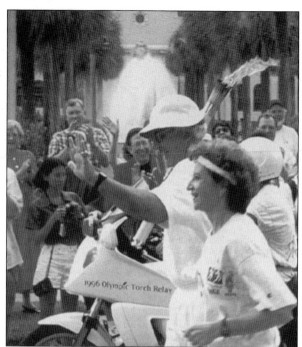

OLYMPIC TORCH RELAY, 1996 OLYMPICS. Head Baseball Coach Tommy Thomas passes West Hall with Dr. Bailey in the background. "Valdosta State University President Hugh Bailey told the audience of thousands that Valdosta was privileged to welcome the Olympic Torch . . . 'May this be a permanent legacy for our city, our nation, and this state.' " (*Valdosta Daily Times*, 7/12/96, p. 1.)

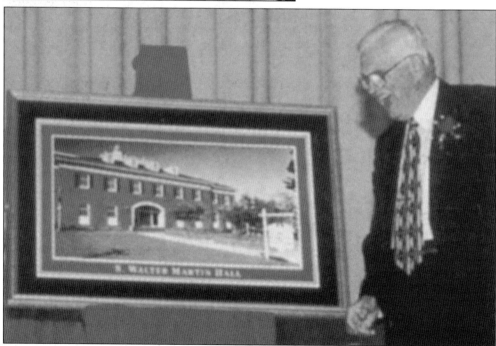

PRESIDENT EMERITUS DR. S. WALTER MARTIN. Martin unveils a picture of the College of Nursing building that will now bear his name. " 'Dr. Martin is one of the most significant educators in Georgia history,' said VSU President Hugh C. Bailey, 'Under his leadership, the college experienced one of its most significant periods of growth and development.' Martin said, . . . 'I do have a very special feeling for the College of Nursing.' " (*VSU Alumni Bulletin*, Fall 1998.)

THE FIRST VSU DOCTORAL DEGREES. Above are Drs. Ellice Passmore Martin, Stephen Holt Pearce, Kenneth Marion Proctor, Elaine Kelly Reichert, and Paulette Brown Taylor, about to receive VSU's first doctor of education degrees. "The College of Education . . . offers programs leading to the Doctor of Education degree, with majors in Adult and Vocational Education, Curriculum and Instruction, and Educational Leadership." (*Ed.D. Program pamphlet.*)

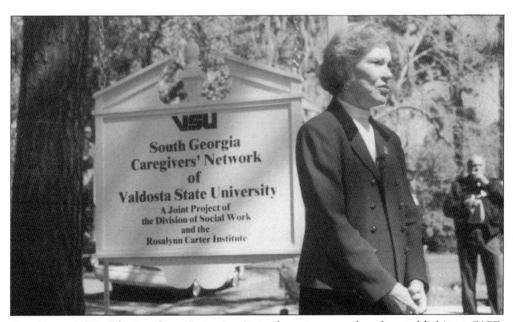

CARE-NET AT VSU. "The Rosalynn Carter Institute chose to expand . . . by establishing a CARE-NET unit on the VSU campus. Led by the Division of Social Work, funding was received from the Robert Wood Johnson Foundation." The purpose of Care-Net is to provide referral and support services for caregivers in the area. (*VSU Alumni Bulletin*, Spring 1999, p. 19.)

THE 2000 BLAZER FOOTBALL COACH, CHRIS HATCHER. Chris Hatcher quarterbacked for Hal Mumme at VSC/VSU from 1991 to 1994 and led the school to its first national playoff. He won the Harlon Hill Trophy, Division II's equivalent of the Heisman in 1994. In his first fall as the Blazer Football Coach, Hatcher had a 10–1 record and a Gulf South Conference Co-championship. (Picture from *VSU Alumni Bulletin*, Spring 2000.)

THE 2001 SCIENCE BUILDING. "The $22.4 million biology/chemistry building is the crown jewel of VSU's campus construction program. When completed the building will . . . hold over 50 labs." (*Spectator* [online], 5/11/00.) The building will be in use for January of 2001. "The concept of the building is to allow students to see science and encourage them do science . . . The building has viewing windows to allow people to see what is happening in labs and several gathering areas." (*Spectator* [online], 11/2000.)